NEW COASTAL INSPIRATION FOR A LIFE BY THE SEA

NEW
INSPIRATION FOR
COASTAL
A LIFE BY THE SEA

INGRID WEIR

Hardie Grant
BOOKS

CONTENTS

Introduction . 11

C O A S T A L

CITY . 13

REMOTE . 45

SURF . 57

COSY . 77

BOHEMIAN . 97

MINIMAL . 129

ISLAND . 147

PANORAMIC . 173

TIPS ON DESIGN AND COASTAL LIFE . . 188

HOW TO CREATE IT 216

Reflecting . 249

Acknowledgements . 253

'BUT THE SEA, WHICH NO ONE TENDS, IS ALSO A GARDEN.'
William Carlos Williams

INTRODUCTION

I was setting out on a journey – to remote beaches, islands, working coastal areas. To see how people live by the sea.

I've always had a fascination with how original thinkers shape their surrounds. How they take what is offered, bend it and work it so that it suits them. As an interior designer, I see good design as thinking made visual. How were people and their design worlds evolving and adapting when it came to coastal living? I was curious to find out.

Two coastal nations – Australia and the United States. Driving the highways and the byways to get to the wilder expanse. Esperance. King Island. The Bay of Fires. Montauk. Malibu. Laguna Beach. Places by the sea often have evocative names.

Warmly welcomed into the homes of strangers – people I had connected with through friends or on Instagram. Invited into their worlds and into spaces that responded to different coastlines. It was stimulating – we had wide-ranging conversations about design and life.

I grew up on a beach north of Sydney. A coastal childhood: building intricate sandcastles, meeting friends at the beach, learning to swim in ocean pools. Constantly in and out of the surf, going under and over the waves. Something a lot of Australians share – the beach and ocean as a presence woven into your life.

Throughout this journey I've been surprised along the way. I've come to realise the power of remote coastal places. What cold-climate environments offer – the life-enhancing feeling after a winter swim. Coastal is more than just being immersed in the water. It's also walking along the beaches in winter. Breathing in the salt air. Being calmed by the rhythmic power of the waves.

I returned from these places filled with energy. The mood and feel of these sweeping coastlines harmonised with the design I was being drawn to – a kind of warm modernism with an organic edge. A calm and simplicity. And always, always, an embrace of the natural world.

'THE MOST BEAUTIFUL THING WE CAN EXPERIENCE IS THE MYSTERIOUS. IT IS THE SOURCE OF ALL TRUE ART AND ALL SCIENCE.'
Albert Einstein

CITY COASTAL

The city behind you, the waves out in front
A different tempo. Seagulls scrapping
Tourists. Fast food. Concrete meets sand
People drawn to the coastal edge
Drenched in ocean energy

DAIMON DOWNEY

BONDI BEACH, NEW SOUTH WALES

'I couldn't get on the plane,' says Daimon Downey.

For eight years, as the frontman of the dance music band Sneaky Sound System, he had toured the world. The United States, Russia, Italy, Spain, Great Britain, Canada – supporting Lady Gaga and Robbie Williams among others. A headline act too, playing at Glastonbury. Living out of a suitcase. But suddenly he experienced a visceral change. 'The tour was leaving for overseas,' he says. 'I was literally, like, I can't do it. I need a pet. I need a girlfriend. I need a fridge. I need a bed. I need pot plants. I need to put my feet on the ground, grow some roots.'

He'd always wanted to be a painter – he left school early to get a fine arts degree. When Daimon made the decision to leave the band, it all happened fast. He moved into his Bondi apartment, turned it into a studio and started working towards an exhibition. Within a few weeks he met actress Georgia Gorman.

It sounds like a prime example of manifestation. But as Daimon himself would acknowledge, there was a rawness to the transition. 'It was so nerve-racking 'cause you're just alone,' he says honestly. 'You're painting by yourself. From making pop music, where you'd play, and the soundboard was the crowd. You could change it, test it. Yeah, the solo vibe, it was lonely but exciting.'

Daimon's upstairs apartment is directly across the road from Bondi Beach. An ocean view fills the bay windows. He lives there with Georgia and their young son Sterling. The colours in the apartment are vibrant but not hectic. The pastel blues and pinks of the space sit well with the sorbet tones of the Art Deco buildings of Bondi. The walls are full of artworks. Key furniture is from MCM House with vintage pieces sourced from online marketplace Curated Spaces.

There's something invigorating about Daimon's presence, like sea air. Maybe it's his can-do spirit. When he was in Sneaky Sound System, they formed their own music label after being rejected by recording companies. Now as a visual artist, he holds his own exhibitions, sells his own work.

'I do exhibitions that are one night only, so they are concentrated. And then you've got two days to go and pick it up. I turn the music up, have great cocktails. Some collective things happen – when things are selling, and people are in the vibe. No closing time. Maybe turn the lights down, put a disco ball up. At midnight people are still chatting away. You can go home with a story of the artwork, how you bought it. The pleasure of the whole process, the atmosphere of it all.'

There's a clarity to Daimon's world. The colours of Bondi buildings, the sea, the artworks, the clothes he wears – it all comes together. We're presented with so many choices in life, so many ways of how to be, it's refreshing when someone has such definition. There's a power in editing down your world.

'There was a time not so long ago when nothing was safe from the brush full of paint ... the piano, the chairs, the kitchen cupboard doors. This lamp is a survivor of those wild times.'

CITY COASTAL

'I've always loved the pastel version of life.'

'I like seeing the horizon; there's a lot of future in the horizon. You can stare at it forever.'

22 NEW COASTAL

'The middle of the window is the horizon; sea below, sky above. We painted the walls blue; so, instantly, it's like you're flooding into it or it's flooding into you. You are living in it.'

BONDI BEACH

NEW SOUTH WALES • BOONDI

Traditional Owners and continuing Custodians: Bidjigal, Birrabirragal and Gadigal people of the Eora Nation

Bondi is always moving.

In the early hours of the morning the boardwalk is full of people running, cycling, walking. The waves glide in towards the beach. People meet the dawn for swims; there are surfers carrying their boards over the sands. There's a pulse.

I lived in Bondi in the 1990s when it was the centre of an artistic, bohemian scene. Bondi itself was gritty and run-down. The sidewalks were full of weeds and the buildings hadn't been painted for a while. My friends were writers, actors and filmmakers; we had meetings about independent theatre shows in a series of Bondi apartments. I was doing costumes and sets and would have fittings in bedrooms and take photos on back lawns and rooftops. Bondi was a creative village, and we only left it to do our day jobs.

Bondi has changed and it hasn't changed at all. Now the shops in Gould Street sell expensive dresses and perfumes from New York. Influencers pose for multiple portraits on the beach. But away from the tourists on Campbell Parade, the locals live the village life in the back streets. Here there is the same mood as in the 1990s, the same scent of eucalyptus and salt. Odd things left in the street by backpackers – busted record players, a pair of Birkenstocks, a ship in a bottle.

Bondi's always had a showy aspect, a raffish quality and charm. It is a magnet for bizarre incidents – like the famous fight at the outdoor muscle gym when one man chopped off another man's ponytail. He shimmied up the lamppost and strapped it around the pole where it flapped like a flag for years afterwards.

My version of Bondi is different now. The Bondi to Bronte cliff walk. The warm welcome at the restaurant Sean's. The feeling you get after swimming laps at the saltwater Icebergs pool. Catching up with friends on the balcony of the Bondi Pavilion during the short film festival Flickerfest. Walks along the beach in the calmer spirit of the winter.

Strip back everything and under all the noise it's still one of the great beaches of the world. There is a unique effervescence to Bondi's water, a particular sparkle and clarity. It's like swimming in champagne. The sand is some of the finest sand, white like snow.

Maybe Bondi is like a classic novel, something you can read at different points in your life, see things you hadn't seen before and get a new understanding.

1. Bondi at dawn
2. The Bondi Icebergs pool
3. 'The Blue Whale' apartment building in Bondi
4. Bondi apartment building
5. Shell whale created by Sean Moran on the ceiling of his restaurant

4.

5.

BISMARCK HOUSE

BONDI BEACH

Bismarck House in Bondi is a new way of imagining coastal design.

It's not about looking out at a coastal view – it is the house as oasis.

A light and open space that merges with pockets of garden. The presence of the ocean is felt in the strong sea breeze. It's a contemplative space that is also stimulating.

Architecture. Landscape design. Interior design. All are interwoven in Bismarck House. A collaboration between the owner – landscape designer Will Dangar – architect Andrew Burges and interior designers David Harrison and Karen McCartney.

From the street it appears to be a traditional Bondi dwelling, but inside Andrew Burges reshapes the volume of the space in unexpected ways. There is the surprise of a large, low kitchen window, almost the whole wall, that opens onto a Bondi laneway. Unconventional, but it works. Upstairs the rooms have swooping ceilings. The walls are a form of concrete rubbed with beeswax. They feel soft but protective.

Interior designer Karen McCartney is well known on the Australian design scene as an influential magazine editor and author of several definitive design books. Her work on the Bismarck House interior benefits from her editor's eye. 'So much of the energy of a book comes from the juxtaposition of the images. That can make it more than the sum of the parts,' she explains. 'What you leave out is as important as what you put in. Then you focus on what is there.' Her pared-back edit of Bismarck House means nothing is overcooked. The interiors have that elusive mix of simplicity, elegance and charm.

As the owner and landscape designer, Will Dangar laughs and says: 'I find it hard, working for myself. Because I don't get a brief!' The garden is a magnificent collection of succulents. A key inspiration was the garden of Isabel Marant's shop in Los Angeles. 'It has an effortless look and doesn't appear to be overly curated,' says Will. 'That is a real skill in design.'

CITY COASTAL

30 NEW COASTAL

CITY COASTAL 31

LUKAS HAAS
VENICE BEACH, CALIFORNIA

'It's a little playground in a way, Venice,' says the actor Lukas Haas. 'Basically, you can step out of your house and the day will just sort of sweep you away. It has all these nooks and crannies to discover. You bump into people you haven't seen forever – end up on a rooftop on someone's house.'

Lukas had lived in West Hollywood for most of his life, travelling the world to work on films. He has only recently discovered living in Venice and life on the coast. 'It's three blocks from my house, and you're in the city but then all of a sudden you're just in nature and you're flowing with the waves,' he says. 'The water is cold water. It can get hot here in Venice, but the water is cold. So, when you get in it's a shock to the system, but you feel *alive* after – you're buzzing; you're tingling and buzzing.'

'There are different, very strong communities here. You don't find that in many places this size. There're tons of surfers. A very tight-knit group of skateboard guys. There are the tourists. The muscle guys. There are a lot of people who just want to live by the water and do their thing, sort of a hippie quality. The homeless are also like a group, and tight-knit too.'

I like hanging out with Lukas. I've known him since we were children. He has a way of making things seem spacious and open, like there is all the time in the world. We go and get a coffee and walk through a web of little lanes that overlook beautifully tended gardens. There's a group of young actors doing a play reading under a tree in one backyard. This is a different Venice to the one I know – the carnival spirit of the boardwalk, with a restless, even dangerous edge.

Lukas's home is small and filled with paintings and ceramics. 'My family is a family of artists,' he says. There are paintings by both his father and grandfather. A vintage tray decorated with iridescent blue butterfly wings was a gift from his mother Emily – a former opera singer and writer, now an artist working with shells.

Lukas's twin brothers Niki and Simon are known as the Haas Brothers. Furniture designers and artists, they have work in collections at Los Angeles County Museum of Art and the Metropolitan Museum of Art. They have shown at Art Basel in Miami. The Haas Brothers create works that defy conventions, all in a mischievous and playful spirit. Lukas has an extensive collection of their vases – they look like strange tentacled sea creatures.

Lukas is drawn to lighting and has recently acquired some ceramic pendants. 'They create this gorgeous amber light; it almost feels like skin, but it's glowing in some beautiful way.' On the outside porch is a Murano glass lantern, and there are clusters of candles scattered throughout his house. I wonder if this awareness of lighting comes from all those years on film sets. He thinks about it, then agrees. 'Lighting is everything on a set. It's always about finding the light.'

There's a record player, a stack of records, a keyboard set up. 'Music is a huge part of my life,' he says. The Beatles are a big influence – their visual style too. 'When you see the Beatles, everywhere they are looks cool: their whole look, their album covers. They always had this very honest but playful and sophisticated combination of things going on. And lots of colours, lots of natural elements – the textures of their clothes and the woods of their guitars.'

Everything in Lukas's life – the art, the music, the beach – seems to be pushing back on the digital world. 'Yeah, I feel like that stuff is the spice of life. My life on my phone is so one-dimensional and limited.' He considers. 'I really don't have much propensity towards being social in that way. My nature is towards the analogue. What means something is what we can taste and feel and smell. But I'm curious about the digital side. I also appreciate plenty of things about it.'

It seems like Lukas is in the right place. 'I've always had a particular connection to the water. The ocean has got a mystery to it. A beauty and a danger,' he says. 'And there's so much life, but it looks so stark in a way. And there's so much movement – the tides and the waves. Because those waves exist in every part of life. Energy in your body or energy coming from stars or the wind or the texture of a piece of wood. The ocean kind of symbolises all of it somehow.'

LUKAS HAAS' VENICE

Retail: Shinola Store

Food: Paloma Venice, Felix Trattoria, Gjusta (especially at night), Gjelina

Coffee: Menotti's Coffee Stop

'I'll just take my bike and ride out along the water's edge. I can't think of many places where I feel as free as I do in Venice.'

36 NEW COASTAL

'Anything I can hang,
I'll hang. Pendants, bells.
It creates an atmosphere
and a magic.'

CITY COASTAL

SAM COOPER
VENICE BEACH, CALIFORNIA

Sam Cooper had opened a little cafe in Venice Beach and found himself working seven days a week, renovating at night.

The industry expert he hired told him he was doing it wrong. 'I was serving in white pants,' he says. 'And in the hospitality industry that's a faux pas – apparently. Who knew? So now you can see that everyone working here wears white pants.' I look around at the waitstaff all dressed in white – it's true. It's a stylish uniform.

Sam Cooper does things his own way. I'm sitting with him in Great White on Melrose, the third restaurant he has opened with his business partner Sam Trude. A large portion of space has been opened up to the elements. Both indoors and outdoors are paved with hundred-year-old cobblestones from Europe. It has a curiously strong effect. Old stones carry their own power. 'They came in huge crates, and we had to take them out, cobble by cobble, and then line them up,' Sam says. 'It was quite a laborious process.'

All the elements in the space are beautiful and unique. The large pendants handwoven in Pakistan. The custom marble tables. The rush seating from France. Then there are the massive beams from an old Midwestern barn, authentic down to the small fissures caused by the methane gas from the cows.

But roll back twelve years and, as Sam admits, 'I was actually quite lost with what I wanted to do.' His background included stints in graphic design as well as real estate. He'd been a DJ. When he came to Los Angeles from Australia to help a friend design and build a restaurant, suddenly all his interests started to converge. He learnt on the job, taught himself the program SketchUp to better communicate his design ideas. Being largely self-taught, he says, 'There's a certain pain that goes with it. You've got to be really committed to isolating yourself and sacrificing a lot of time.'

I'd heard that one of the waitresses at Great White had become a member of the interior design team. 'That's Maddy,' says Sam. 'She asked us if we needed any help with the design. She could use SketchUp and so we started her off ... we've given her a lot of decisions and accountability for a junior designer. In our design process nothing is sacred – the best idea wins.'

This is part of an ethos of promoting from within, something important to Sam and his business partner. There's a noticeable esprit de corps shared by the people working in the restaurant, a sense of loyalty. They don't feel boxed in. Sam's own sense of freedom and fluidity has translated to others. It adds an intangible layer to the atmosphere of Great White.

'The speakers were made by Devon Turnbull in Brooklyn. They took six months to make. People come in to photograph them all the time.'

Above: Great White on Larchmont Boulevard **Opposite:** Painting by Rafael Uriegas

'WE NEED THE TONIC OF WILDNESS.'
Henry David Thoreau

REMOTE COASTAL

To absorb through your own senses,
Out in nature. A band apart
The remoteness fills you up with something.
The difficulty makes it more precious.

WESTERN AUSTRALIA

A PLACE OF RARE MINERALS & STRANGE SEA CREATURES

There have been many unusual discoveries made over the last ten years on the coast of this remote and underpopulated state.

The largest known dinosaur footprints found along the Kimberley shoreline

An ancient and enormous seagrass plant, the largest known plant on earth, found in Shark Bay

A ruby seadragon washed up on Ocean Beach, discovered by a schoolteacher

A field of floating 'translucent pom-poms' made up of rare marine creatures, found in the Kimberley; only ever spotted a handful of times across the world

A 'fluffy' crab that wears a sponge as a hat; a new species, found washed up on the sand by a family in the Great Southern region

A rare golden pearl found in Broome by a woman on her 70th birthday

A four-billion-year-old piece of the earth's crust, the size of Ireland, beneath the South West coast.

ESPERANCE

WESTERN AUSTRALIA · KEPA KURL

Traditional Owners and continuing Custodians: Kepa Kurl Wudjari people of the Noongar Nation and Ngadju people

'You got the glamorous Western Australian sunset,' said Fiona Shillington, owner of the Esperance Chalet Village.

She'd seen me return exhilarated from the Great Ocean Drive – beach after perfect beach, the sky washed in soft mauves and pinks, the air thick with salt. Stopping along the way on the high cliffs, looking down at the tiny surfers. A lone windmill catching the last light on the beach. A huge granite formation that looked like an elephant's foot stamping the edge of the continent.

The trip to Esperance had started from a small terminal airport in Perth in Western Australia, arguably the most isolated capital city in the world. The airport seemed to have an unstated dress code: boots with steel caps – men and women alike; serious heavy fluoro jackets with big pockets; dusty utility pants and small backpacks. This was the FIFO community – the fly-in fly-out miners. I liked the strangeness of feeling out of place. It felt like real travel, going somewhere unknown to most.

I'm staying at the Esperance Chalet Village, an endearing little cluster of A-frame buildings. It's an old scout camp, renovated by owner Fiona, a former TV publicist. She's been clever in retaining the charm of scout-like activities – bikes, kayaks, bonfires. But the beds have luxurious linen sheets from Western Australian brand Bedtonic, and there's an elegant Scandinavian colour palette. The lawns are fringed with banksia, paperbarks and saltbush. There are horses in the paddocks; just past a track heading to the creek. It's very peaceful, especially lying in the hammock.

Esperance exploded onto the world stage in 1979 with the spectacular disintegration of the US Space Station Skylab. It appeared after midnight as a fiery apparition, accompanied by six sonic booms, rattling the town's doors and windows, scattering debris and space junk. One enormous oxygen tank lay undiscovered in a distant paddock for fourteen years. A shire ranger with a sense of humour fined NASA $400 for littering.

REMOTE COASTAL

The town of Esperance has an appealing village-like layout. The buildings are from a pragmatic era of Australian seaside dwellings. There's a fish-and-chip shop sign with bulging red and yellow letters – in a font that could be called '1980s fish-and-chip shop'. A few doors down sits Woven boutique, stocked with upmarket international clothing labels. The community seems tight-knit and friendly at the morning coffee stop, Cloud Eleven.

I head out to Lucky Bay in the remote Cape Le Grand National Park. I'd seen photos of kangaroos lounging on the flour-white sand, turquoise water in the background. Halfway there the GPS goes offline; I have to navigate the old way. Thrown back on instinct, I need to pay more attention. The world outside the windows seems closer.

Leaving Esperance I park one last time on the headland above the beach, next to the bent and twisted trees, and look out to the islands of the Recherche Archipelago, which appear on 17th-century Dutch maps. The wind off the Southern Ocean causes the car to rock while stationary.

One translation of Esperance, from the French, is 'hope with confidence and faith in the future'. It feels fitting. Esperance is a place full of potential. I don't know what form it will take in the future. Maybe it doesn't need to unfurl to its fullest. Maybe it is good as it is, a stepping-off point to wild and exquisite nature.

1. Beach in Esperance
2–3. Esperance Chalet Village

2.

3.

REMOTE COASTAL 51

1. Lucky Bay
2. Esperance garden
3. Esperance Chalet Village
4. The road out to Lucky Bay
5. Down Town coffee in Esperance

52 NEW COASTAL

4.

5.

REMOTE COASTAL 53

Above: Shell chandelier in the Esperance Chalet Village made by Fiona's husband Matt, from left-over abalone shells
Opposite: Beachside track in Esperance

'THE HEART OF MAN IS VERY MUCH LIKE THE SEA,
IT HAS ITS STORMS, IT HAS ITS TIDES AND, IN ITS
DEPTHS, IT HAS ITS PEARLS TOO.'
Vincent van Gogh

SURF
COASTAL

Big waves rolling in
A life filled with the ocean
Looking in to the land from the water
A different rhythm. A coastal community.
Offbeat. Risk-taking.

MONTAUK

NEW YORK

In the summer of 1975, when Mick Jagger was staying in Montauk, the photographer Peter Beard would take him to the Shagwong Tavern to hang out with the surfers and lobstermen.

Every single time they walked in, a local prankster would put on 'Get Off of My Cloud'. It was the only Rolling Stones song in the jukebox. A favourite Shagwong anecdote tells of the night Mick Jagger finally retaliated. Fed up, he put on the disco hit 'Shame, Shame, Shame' and sang along with it in falsetto.

I'd headed out to Montauk in October, the off season. Driving through long tunnels of trees, surrounded by generous swathes of public parkland. There were roadside signs warning of wild deer. Clusters of pumpkins stood on farm-stand displays, the oranges vivid against the grey skies. Montauk is sometimes called The End – only the Atlantic Ocean lies between it and Ireland.

I wasn't sure what I'd find. I'd read of Montauk's past bohemian glory. Seen the black-and-white photos of the old fishing lodge owned by Andy Warhol, the interior flooring made of New York pavement. But recent articles describe Montauk as a summer party town, overrun by private equity executives and social media stars, with the locals battling to save its soul.

A visceral blast of oceanic energy hits me as I open the balcony door of my second-floor room at the Marram Montauk hotel. The view is straight out to sea, and the pounding surf reverberates with a deep intensity. Nature feels very close. Rugged up on the balcony and staring out to the horizon feels like being in a great gallery, awed by a powerful installation.

SURF COASTAL

The hotel becomes the frame around my experience of Montauk. It's a contemporary makeover of an old motel, right on the sand dunes. The style is warm modernism with a Moroccan influence. In the morning I have wide-ranging conversations with James, the old man running the breakfast bar. We talk about world affairs; his home country, Jamaica; and mine, Australia.

There could be a whole travel book about visiting seaside towns in the off season. You lose and you win. It's the moon to the sun. No balmy days but bracing cold-water swims. Long walks on a windswept beach, deserted except for a few dog walkers and some surfers. It reminds me of a movie, but I couldn't remember which one.

The next day I drive half an hour into Amagansett, exploring its enticing array of stores. Warm Store. Nellie's antiques. The restaurant il Buco and the accompanying homewares store – filled with handmade treasures from Italy. I visit the Marine Museum and learn about the whalers, who could go to sea for up to five years at a stretch. There's an enormous fin whale skull – the size of the creature is overwhelming.

I leave Montauk refreshed by salt and water. It's interesting visiting a place alone. Sometimes it can be a strong slice of experience – without a companion, you notice more. There's still some wild energy in Montauk. The last building I pass on the way out is the Memory Motel. The one and the same from the Mick Jagger song.

1. Fin whale skull at the East Hampton Marine Museum
2. il Buco Restaurant
Opposite: Outdoors at the Marram Montauk hotel

1.

2.

3.

1. Marram Montauk hotel
2. Seating outside the Clare Vivier shop in Amagansett
3. Montauk beach
4. Balsam Farms Montauk Market

62 NEW COASTAL

4.

SURF COASTAL 63

AMEÉ ALLSOP

THE HAMPTONS, NEW YORK

Designer Ameé Allsop is quoting John Pawson: 'Minimalism is not defined by what is not there but by the rightness of what is and the richness with which this is experienced.'

I'm sitting with Ameé in her calm and beautiful living room in the Hamptons, and it makes sense hearing about the influence Pawson has had on her design. 'There is a poetry in his work that feels balanced between modern and traditional,' she says. 'The materials are put together in a thoughtful way. I like to think of it as a quiet luxury.'

Before I visit Ameé, she sends me a list of things to look for on my visit to the Hamptons. It's a nice mix of rustic farm stands with high design shops. I go to the Amagansett Square and have a delicious coffee and French-style baguette on a seat overlooking what feels like a village green. I had been up and down Main Street a few times but wouldn't have known it was there.

Just a few years ago Ameé was living in Brooklyn with her husband Glen, a photographer, and son Navy. An architect, she had trained in her home country, Australia. 'Architecture taught me how to pay attention to the details, be curious about how things are put together,' she says. 'It makes you question everything, but especially how to live.' For her clients and herself. 'At the time, we realised we were just missing the ocean.'

Ameé and Glen can move fast. In one day, they saw five houses and bought the last one. The beach is five minutes away. To my eyes, it is a spacious and lovely home, but Ameé laughs and says it is considered very small by Hamptons standards. It's a traditional design, built in the 1980s – a solid post-and-beam construction with cedar shingle cladding. Everywhere you look is a window to nature. The dappled woods outside are framed like paintings on the wall.

Alongside the move from city to coast, Ameé made the transition from working in an architectural firm to establishing a studio of her own. Her work spans furniture design, objects and interiors. Now with a second son, Finn, it was a lifestyle choice as well: 'I wanted to be around as much as possible, but I need to always be creating something.'

This confidence to pursue her own path had its beginnings in her first job, working for renowned Australian architect Peter Stutchbury. 'He was a wonderfully challenging mentor. He pushed us to never use anything off the shelf. He would say: "we can make that better" – customise door pulls, tapware, sinks, etc. Which is tough. But it puts you in the frame of mind where you think differently.'

Ameé's work is inspired by nature. She starts with a material, does research and makes sketches. 'It might be something made of stone or metal or wood. Having the architectural background, working with different artisans came naturally. I realised I would come alive in that conversation and process. I was in my happiest mode.'

Living full-time in the Hamptons is different to the summer visit. 'Everything shuts down. It is quieter. It's a good time to dream of new designs. We cook more at home and have friends over, drink cocktails by the fire. Just living with the seasons.'

Later Ameé and I visit Michael Del Piero Good Design Hamptons. A low-slung whitewashed barn filled with sumptuous monochromatic treasures: one-of-a-kind artefacts from Japan, Sweden and Africa. Elegant modern furniture too, including Ameé's designs.

We go for a walk on Wainscott beach. 'It's a very minimal beach landscape,' she says. 'Not that it goes forever, but it's very sparse.' I can picture her walking along the grey beach, surrounded by the pale yellow seagrass, thinking on her future designs. She acknowledges it's a good place for a reset. 'Just to have that space sometimes – just somewhere to go and have peace.'

Good Design Hamptons

AMEÉ ALLSOP'S HAMPTONS

Retail: Nellie's of Amagansett, il Buco Vita, E-E Home, Good Design Hamptons, Wyeth Furniture

Food: Doubles Amagansett, il Buco al Mare, Carissa's the Bakery, Levain Bakery

Farm stands: Balsam Farm, Amber Waves Farm Market and Cafe, Round Swamp Farm Market and Bake Shop

SURF COASTAL 69

'The starting point is figuring out how you want to live. Beyond that it is light and orientation.'

TIPHAINE DE FLEURETTE

APOLLO BAY, VICTORIA • KRAMBRUK

Traditional Owners and continuing Custodians: Gulidjan and Gadubanud peoples

Tiphaine de Fleurette is talking about the people who live in the trees.

At first, I'm puzzled. A literal treehouse community? I'd entered Apollo Bay through the mists on the mountain road lined with tall trees and low ferns. Driven past the colonnade of massive, gnarled trees that line the seashore. I hadn't noticed any treehouses, but it seemed entirely possible given this dramatic and magical terrain.

Turns out the reference is more symbolic. Tiphaine, a website designer, is referring to the people teaching and practising alternative healing therapies in Apollo Bay: Pleiadian light works, qi gong and yoga. 'The people who live among the trees – they have absorbed so much of the energy of this place,' she says. 'That childlike quality, very open. And that's the energy that I want to absorb. It's just like feeling the sunshine, feeling the ocean.'

It seems to me that she already has – she radiates energy. And she has poured it into a dilapidated, unloved old hall near the Apollo Bay docks, turning it into a flourishing arts and community centre: Floreo Creative. 'I wanted to create a space for my children and me to be happy. And to create a community and bring everyone together.' It is entirely self-funded, with help and favours from volunteers and friends. Plus the proceeds from the coffee truck she has started outside. Tiphaine is a one-person arts and cultural festival.

But it has been a process. 'This is very much a surf town. I'm not a surfer. I had to find my way of connecting with it,' she says honestly. 'I'm from the tropics and this is a temperate rainforest.' Tiphaine grew up in Belize, in Crooked Tree village, then the world's biggest bird sanctuary, and Belize City. She is a mestiza, of Mayan and European heritage. 'I have lived in a lot of places – Cyprus, Scotland, England, Berlin,' she says. 'I've worked in galleries and as a professional artist.'

She was on holiday in Australia when she met Jordie Brown, a custom surfboard shaper, at the Bells Beach house of a big wave surfer. Eventually she moved to Apollo Bay to be with him, then they married and had two children. 'It's the longest I have ever been anywhere,' Tiph says.

It's a moody, grey day when we meet; the ground is waterlogged. We go back to her house and I meet Jordie, who is shaping boards for his company, High Tide Surfboards, in a backyard cabin. Though Tiph and Jordie are no longer together, their separation is amicable.

Jordie explains how his work is counter to the current surf industry, which is geared towards mass production. 'I'll meet with someone. I'll have a surf with them and I can really weigh up what they need,' he explains. 'I can have a better chance of getting them on their perfect board.'

SURF COASTAL 73

He asks if I want to see where he does the fibreglassing of the boards. We drive up corkscrew roads in the hills above Apollo Bay, then veer off on to a dirt track to his workshop. Clouds are hugging the landscape.

'Shaping is one side of it, but the art is in fibreglassing,' he says. 'To teach someone to glass, it's a couple of years.' There is the remnant of a toxic smell lingering in the shed, and I wonder how his lungs cope. He tells me he does long runs through the clear mountain air. He takes me to the top of a secret waterfall in the forest nearby. It is one of the most beautiful things I have ever seen.

We head back down to the bay to meet Tiph. The sea beyond looks rough and choppy. Jordie knows Bass Strait well. 'Yeah, it's colder; it's a bigger mass of water, it moves differently.' Tiph agrees: 'I have learnt to embrace the wildness. The windy, rainy days and the storms and the howl. During winter it's almost like Wuthering Heights.'

The Winter Wild Festival captures this mood. At the heart of it is The Dogwatch, a fire performance on the dark foreshore. 'A really keen artistic crowd come together,' says Tiph, 'and it also brings out the people from the trees and gets really crazy.'

There's a lot going on in Apollo Bay and Tiphaine seems to be at the heart of it. So, I'm surprised by her confession at the end of my visit. 'I'm actually a really private person who nobody knows very well,' she admits. 'I have a surface level that everyone knows extremely well and then it goes *dink* and you hit a wall and it's just like "*secretive*". But I'm opening up now, and it's really, really been good for me to trust in life.'

TIPHAINE DE FLEURETTE'S APOLLO BAY

Retail: The Pombomart (a completely weird little beast which is open on random days, full of curios and vintage finds)

Food: Forage on the Foreshore in Port Campbell, The Perch at Lavers Hill

'AND A SOFTNESS CAME FROM THE STARLIGHT
AND FILLED ME FULL TO THE BONE.'
WB Yeats

COSY COASTAL

Blazing fires made of driftwood
Taking shelter, hunkering down.
A lamp glowing outside to greet you
Candles. Salt in the air. Soft blankets.
Snow falling through the night. Snug inside.

BAY OF FIRES

TASMANIA • LARAPUNA

Traditional Owners and continuing Custodians: *palawa people*

It feels like the cabin of a fisherman, maybe one who is also an artist. It could be in a remote village on the coast of Japan.

But it's not. It's a short-term rental house called Sabi Stays in the Bay of Fires. The best design evokes feelings and mood. It stimulates the imagination …

It would be a good place to write a novel – even calling it Sabi Stays. I see the author, up early, writing for several hours. Then a long walk through the beaches, lagoons and rocky bluffs. Climbing over the dramatic boulders covered with orange-coloured lichen. A shot of Japanese whisky in the evening; correcting proofs. Weekends heading into St Helens, the nearby fishing village, to get provisions. Maybe a stop at the Lifebuoy Cafe to have coffee and cake and chat with the locals.

But only a prolific author could get much done because time at Sabi Stays is at a premium. It gets booked out fast. People recognise something unique and handcrafted, and the love that has gone into creating it. It was designed and renovated by Jessica Eggleston and her husband Fred. A forensic psychologist in her day job, this project gave Jessica the opportunity to cross over from her left brain into her right.

The inspiration flowed after Jessica discovered the Japanese philosophy of wabi-sabi, and she spent months researching its principal tenets. Beauty in imperfection, impermanence, simplicity, honesty. Rough pavers are used for the interior flooring – it's an unusual choice and evokes a Japanese temple. Jessica describes how the landscaping supply shop was surprised by her wanting the chipped pavers. She even asked them to hammer off some more fragments.

People think that the Bay of Fires is named for the orange-red colour of the rocks. It's not. It came from British navigator Tobias Furneaux who saw the fires of the First Nations people from his ship. There's a general greyness to Tasmania; the landscape, the skies. This is pierced by the brilliant red and gold sunsets and the same fiery boulders. There's poetry in this contrast; the severity and plainness with the passionate colour. That same poetry is in the Sabi Stays cottage, linking it intimately to the surrounding nature.

1. Cosy Corner in the Bay of Fires
2. Muka in Akaroa cabin
3. The Lifebuoy Cafe, St Helens
4. Sabi Stays
5. Cosy Corner

84 NEW COASTAL

4.

5.

Above: Cosy Corner in the Bay of Fires **Opposite:** Night falls at Sabi

KATIE BOWES

PORTLAND, MAINE

Katie Bowes' house in Maine looks like a contemporary Scandinavian farmhouse, even though it is over two hundred years old.

The skilful effect was achieved by Katie's husband Brad removing the shutters and replacing the horizontal boards cladding the building with boards running in a vertical direction. The verticals emphasise the simple lines of the original house.

Katie is living the new coastal life. She and Brad made the move from Brooklyn to just outside Portland several years ago. As she tells it, they wanted to start a family and had a vision of 'grass stains on their knees, a bursting vegetable garden and a strong sense of community'.

They are part of a new influx of people who have found their way to Maine from big cities like New York, Boston and Chicago. 'People in their mid-twenties to mid-forties, who don't yet have families or have very young children,' Katie explains. 'There is a great energy and enthusiasm for all the local businesses popping up and places to explore within the state.'

This fits with something I've noticed on my coastal travels – new generations moving to colder coastal areas and living with the seasons in a different way. The cold-water swimming movement is big in Maine. Katie sees it as part of a cultural shift – with a focus on health and longevity. 'Embracing the season versus fighting against it,' she says. 'Looking to Sweden, Denmark and Japan for inspiration and ideas.

'Katherine May wrote a beautiful book called *Wintering*,' Katie adds. 'In winter there is a leaning in – an emphasis on lighting candles to remember the light, of cooking warming foods, of a quiet energy. Accepting that this is a reflective time, a cosy time. Not fighting against it. Just knowing the snow will melt, the flowers will unfurl and with that comes a big out-breath of energy – gardening and beach trips and visitors flooding through.'

Maine has been full of fresh starts for Katie and Brad. They are now the parents of two small children – Jasper and Juniper. Katie has also started a new business, The Post Supply, in Portland. It's a modern general store with a curated mix of traditional utilitarian goods, art and design books and handmade products. Something that was a long-held dream, from back when she was a freelance prop stylist in New York. Starting out, Katie had been looking around for a space to lease and nothing clicked. 'Eventually, through long walks with my dear friend Hannah Haehn, I realised what I truly needed to get started was a business partner. And that was Hannah!'

Katie is a great connector of people and places. We met on Instagram, introduced by the stylist Anne Parker. Katie had sent me a detailed guide to Maine – restaurants with delicious food, stylish modern clothing stores and seafood roadside stops – recommending which little towns to visit on a road trip. Her generosity deepened my experience.

I see that same connecting spirit when she talks about the makers they represent in The Post Supply. 'My friend Tessa owns ØGAARD and works with glassmakers out of Mexico,' she says. 'Then there's Anemone Delvoie, a self-taught ceramicist from Big Sur. Her playful, experimental approach feels so refreshing and fun. Our friend Cristiana makes olive oil on her family farm in Greece: Oracle Oil.' These products aren't just things – they are related to people and the process by which they were made.

Maine was a memorable trip. Back in Australia I reflect on Katie's New Year resolution; there's something of her pioneering spirit about it. 'I've declared this year the year of *in-person* experience. Of grabbing chances to connect by the horns. Of making and keeping plans. Of stocking snacks on hand at all times for impromptu hangs. Of getting out of my quiet routines and into spaces with my loved ones. Of balance, always, but connection first.'

KATIE BOWES' MAINE

Retail: Folk, Onggi, Judith, Goods, Daughters, The Lost Kitchen, Strata, Gus & Ruby Letterpress

Wine/Spirits: Oyster River Winegrowers, Maine & Loire, Luce Spirits, Table Bar

Food: Leeward, Sammy's Deluxe, Quanto Basta, Double Grazie, Izakaya Minato, Anju Noodle Bar, Wolfpeach, Mr. Tuna, Ramonas, LB Kitchen, Victoria Nam/Siblings Bakery, Briana Holt, Sonya & Bernice

Coffee: Tandem Coffee, Smalls

Other: Washington Baths, Glidden Point Oyster Farms, Dunes Art Gallery, Seven Lakes Inn

'Rebekah Miles is an incredible artist based out of California. The tiles she painted on our backsplash make me so happy.'

92 NEW COASTAL

'Embracing the season versus fighting against it,' Katie says. 'Looking to Sweden, Denmark and Japan for inspiration and ideas.'

Opposite: Portland Breakwater Light (Bug Light) **Above:** Small wooden sculptures by Katie's husband, Brad Bowes, Joiya Studios

'SOME KIND OF RELAXED AND BEAUTIFUL THING
KEPT FLICKERING IN WITH THE TIDE.'
Mary Oliver

BOHEMIAN COASTAL

Traces of sand in the house
Flea market finds chosen with care
World treasures brought back in suitcases
Luscious fabrics, slightly worn
Barefoot afternoons in the sea breeze

DEE TANG AND DESMOND SWEENEY

FREMANTLE, WESTERN AUSTRALIA

'Approach it like you're in a new city,' was a friend's advice to Dee Tang when she moved back to her hometown of Perth.

'Because *you* are a new being. With new values and beliefs, things you're interested in. Be present with that, and in that state you will connect with different people.' Since the move, Dee has done just that, connecting with 'some really amazing artists and creative people'.

For stylist and author Dee, the only place she could consider living was Fremantle – the artistic coastal enclave. Together with her husband Desmond Sweeney, an artist, and their children Rafa Rose and Beau Sunray, they found a magnificent house dating from the 1940s – Californian bungalow in style. Dee named it the Lady California.

Previously home to a Scottish family of glass artists, when they moved in the rooms were painted in bright colours. 'In the start we were just sort of patching and painting,' says Dee. 'Feeling her bones. She's so beautiful.' They were overwhelmed by a new sense of space. 'Finally, it just felt like we had a house we could expand into.'

It's hard to imagine the Lady California being any other way than it is right now. Dee's style is so intuitive, it is at one with the architecture. The neutral palette with touches of soft colour is calm and inviting. 'What I love is setting up a scene, be it for fashion or homewares or lifestyle,' says Dee.

There are beautiful textiles, individual curios, vintage finds picked up from the Melville Markets. 'It's the best flea market in the state, and it's just up the road,' says Dee. 'I go there every Sunday.'

Desmond has set up a painting studio out the back. As well as holding exhibitions, he also works as a large-scale mural painter. He uses a condensed middle range of values: no darkest dark, no lightest light. Like a faded polaroid. There is a lot of the sea in his dreamlike work. It fits that he's a surfer, too. As he puts it: 'In any moment in my life, when there's been trauma or loneliness, it always culminates in spending hours staring at the ocean. And sitting in it, waiting for waves.'

Dee's first book is called *Love Is,* and she is both writer and illustrator. It is filled with the spirit of what Dee calls her Angel Child: her daughter Kawa. When she describes the premise of the book this leads to talking about their family tragedy – the loss of their much-beloved Kawa. 'It's actually about who we are,' says Dee. 'Why we are how we are.'

The word grace comes up. It is Desmond who mentions it first. 'I had thirteen years of Catholic schooling,' he says. 'And only when Kawa passed did I understand what grace was. And the real meaning is about what you are given on the other side. Now you get the gift of grace.'

There's an energy that permeates the Lady California. Not in a sad way – the opposite. It's a house full of love and children and lightness. Maybe there is something of an extra radiance to its beauty – a touch of that grace.

100 NEW COASTAL

BOHEMIAN COASTAL 101

NEW COASTAL

104 NEW COASTAL

BOHEMIAN COASTAL 105

FREMANTLE

WESTERN AUSTRALIA • WALYALUP

Traditional Owners and continuing Custodians: Whadjuk people of the Noongar Nation

The spacious streets of Fremantle are lined with beautiful and ornate limestone buildings.

If you covered the bitumen road with dirt and hay and obscured the parking signs, it could be a prosperous port city on the Indian Ocean in the 1850s.

But there's a beat of nowness too. A university. Craft breweries. Architecture firms. Bookstores. A vinyl record shop. A chart and map store that would be the perfect setting for a romantic comedy. Beaches in the middle of the city.

I'd heard a few things about Fremantle before I came. It was famous for its music scene and had been for a long time. Then there was the Fremantle Doctor. I wasn't sure what that meant … possibly a local cocktail? But it refers to the summer sea breeze that arrives in the afternoon and cools everything down.

It's a good place to wander and explore, Freo. I pass an arresting wall mural of a man floating face up in the ocean – one of six Irish convicts, known as the Wild Geese, who arrived in 1868 on the last convict ship sent to Australia. After eight years in the Fremantle prison, the men purchased a whaling ship and escaped from a work gang. The Wild Geese sailed to America and lived the rest of their lives as free men.

The mural has a power and draws the eye every time. I read later that the artist, Fintan Magee, was inspired by Irish mythology and an otherworldly realm known as the 'Land of Youth' – Tír na nÓg. It can be reached by entering ancient caves, travelling across the sea, or turning into a bird and flying there.

BOHEMIAN COASTAL

MATILDA BROWN

WHALE BEACH, NEW SOUTH WALES • GURINGAI COUNTRY
Traditional Owners and continuing Custodians: Garigal/Caregal people

Matilda Brown spent the early years of her life in Whale Beach. 'I think your body remembers it,' she says. 'That feeling when you take your shoes off and step into sand.'

A few years ago she moved back into her old family home, with her husband Scott Gooding, their young children Zan and Anouk and her stepson Tashi. 'At the beach I feel so much lighter,' she says. 'So much calmer within myself.'

Whale Beach is to the north of Sydney. Heading up from the city, you feel something change when you drive through the nearby Bilgola Bends. As the car hugs the twisting, curving road, you can see the ocean below and green hills, lush foliage above. As Matilda tells it: 'It's an amazing entrance. It could be something out of *Jurassic Park*. I say to my son Zan – can you see any dinosaurs up there?'

Matilda's background is in acting and directing. But for now, her priorities have changed. 'I've taken a big step away. When you have kids, time feels more precious.' She still has an agent and is open to a return in the future but is realistic about the industry. 'It's *such* a gamble.' She and her husband Scott have started The Good Farm, selling prepared meals. 'It's something that I really believe in and fully control, whereas acting was never something that I could control.'

The Good Farm is built on Matilda and Scott's shared passion for organic food and a high standard of animal welfare. It is aligned with regenerative farming, which works on the principle of strengthening the soil and the land. 'We work together pretty well as a team,' says Matilda, of going into business with Scott. 'We have the same vision for it, so that helps. Then of course we have days where if we were an employee we probably would have been fired!'

She has a rare quality, Matilda. When she is having her portrait taken, she can look straight down the barrel of the lens. No projection of an image or an ideal self. She is just there.

She has that same bare honesty online too, where she documents the behind-the-scenes reality of starting a small business and raising a young family.

The move to the coast has been a reset. 'Every night when I get into my bed there's sand in it,' Matilda tells me. It's true indoor–outdoor living. Most of their time is spent on the deck, with its sweeping ocean view. There's a fully working outdoor bath on the side verandah, under a palm tree. The pink painted living room is breezy with ocean air.

It's a coastal childhood, repeated. Matilda is giving Zan and Anouk those same experiences she grew up with, increasingly more precious now in our digital world; the beach as a place of creative play – a world of exploring rock pools and building sandcastles. 'Watching the whales and dolphins when they pass by, putting your finger in the sea urchins,' Matilda says. 'Just exploring and getting lost.'

'Every night when I get into my bed there's sand in it.'

LAGUNA BEACH

CALIFORNIA

Laguna Beach has a forgotten past.

A century ago the local beaches were a silent-movie hotspot.

They stood in for Cape Cod, the South Seas, Treasure Island. Production designers built lighthouses and whaling villages, carried in palm trees and constructed Italian cottages on the cliff. United Artists was the momentum behind Laguna's silent-film rush – founders and friends Mary Pickford, Douglas Fairbanks and Charlie Chaplin all had houses in Laguna.

In the Prohibition era, Tony the Hat, one of California's most famous rum runners, smuggled whiskey into Laguna's secluded coves. His shrimp boat would moor off the coast and black-painted skiffs delivered the alcohol under the cover of night. If there was a threat of discovery, the crew would lower burlap sacks of bottles overboard. Later some would wash up on the sands.

Laguna Beach has always attracted dreamers. Artists were drawn to its natural beauty early on. It was a centre of the psychedelic counterculture in the 1960s; Timothy Leary had a house on the beach. For decades the town had a famous gay scene centred around the Boom Boom Room and the Little Shrimp piano bar. Today it's mostly perceived through the eyes of another kind of dream – reality TV.

Going for a sunset stroll along the clifftop park is to walk through amazing vistas, looking down over bougainvillea and cactus to small beaches and inlets. The air seems very thick with salt, maybe something to do with how the spray hits the coves. In the town itself there is liveliness at night, people chatting in cafes, music floating out of taverns. Large outdoor restaurants are lit by columns of fire.

Early one morning I make it down to what is known as the Pirate Tower. It is actually a practical structure – a staircase from a private house down to the beach. But in the pinky-blue softness of the sunrise, surrounded by waves from the incoming tide, it becomes something ethereal. A portal back to that early bohemian past. A few coves to the south, you can imagine Errol Flynn's Captain Blood is still in a deadly sword fight with Basil Rathbone. And looking up to the hills to the north, Paul Henreid is still lighting Bette Davis' cigarette in the Rio de Janeiro of *Now, Voyager*.

BOHEMIAN COASTAL

116 NEW COASTAL

My preference is for the Casa Laguna Hotel. A former artists' colony in the Spanish Revival style, it's small, quaint and charming. A refurbishment by designer Martyn Lawrence Bullard has given it a fresh feel.

VICTORIA SMITH

LAGUNA BEACH, CALIFORNIA

The first visit to Laguna Beach I stayed at the romantic 1920s Spanish Revival Casa Laguna Hotel and saw the rest of the town through a rose-coloured filter.

I had found the hotel on Victoria Smith's blog – an enticing mix of modern meets Parisian bohemian vintage style. Now I have returned to Laguna Beach to meet Victoria in person.

Victoria carved out an early stake in the online design world. She started her blog San Francisco Girl By Bay in 2006 as a hobby. She was working in advertising at the time, with a roster of heavyweight clients. A couple of years later, when her blog started taking off, she quit her job, heading off into the internet unknown, bolstered with savings accrued from her Etsy store.

It all worked out. She was instrumental in helping Pinterest get established, collaborating with them after meeting CEO Ben Silbermann at a conference. Now, moving with the times, she has shifted SFGirlByBay over to Substack.

I'm staying at a different hotel this time and Laguna doesn't feel as unique. More like other beach towns. But wending my way through the back streets to Victoria's Spanish Revival cottage, the charm of Laguna Beach reappears, full and vigorous. It's a delightful little house: whitewashed walls, teal shutters – set in the grounds of a magnificent cactus garden with glimpses of the ocean. She moved here from Los Angeles a few years ago.

'I have a closet full of clothes from LA, but I basically dress like I am at camp,' she says. 'T-shirts, khakis, flip-flops, cut-offs.' Here indoor and outdoor living merge. 'Every weekend, I am outside on my chaise reading. I have an outdoor bathtub, so I'll fill that up with cool water and a little bit of hot, and just take dips.'

The move to Laguna has been a good one. 'I think it's a hidden gem. Even though it's not that far of a drive from LA, it's kind of tucked away,' she says. 'It's a mix of people. There's a lot of artists, a gay community, and the canyon can be kind of funky.'

Victoria is now immersed in the local community and gives me a list of several design and homewares shops to visit. 'My friend Dana, who runs Good Together House, she has lived here her whole life. Her son went to high school here. We'll go to an event together, and we can't go five feet without them knowing someone.'

It's pleasurable spending time in Victoria's house; it's light and airy and filled with beautiful things. Brocante found in French flea markets; shelves stacked high with art and design books. Victoria's great grandparents owned a circus in the 1930s and there is something of that spirit in her collections. Her brother, who likes new houses, commented: 'This would be kind of cool if you painted it!'

This is the seaside as an imaginative way of living. 'Last night I looked out and there was this huge moon,' she says. 'There were ships out there with their lights on. I like the sound of the waves. When there are really big waves, I can hear them here at night.'

VICTORIA SMITH'S LAGUNA BEACH

Retail: Good Together House, LaLa: A Kerry Cassill store, Areo Home, Tuvalu Home, Laguna Beach Books, ARTime Barro (a ceramics studio with students' works for sale)

BOHEMIAN COASTAL 123

'If you decorate with things that you love, you'll build a house that's meant for you, and it won't look like anybody else's.'

126　NEW COASTAL

'I like decorating with black and white and neutrals. Add colour when the seasons change – with cushions and throws.'

BOHEMIAN COASTAL

'AT SEA I LEARNED HOW LITTLE A PERSON NEEDS,
NOT HOW MUCH.'
Robin Lee Graham

MINIMAL COASTAL

Simplicity works by the sea
Most things removed,
Objects now more precious
More space in between
Attention focused on what remains

MIRANDA GEIGER

MARGARET RIVER, WESTERN AUSTRALIA • WOODITUP

Traditional Owners and continuing Custodians: Wadandi and Pibelmen peoples of the Noongar Nation

Visiting Western Australia when you live on the east coast feels like coming out the other side of a mirror.

It's familiar, but not everything lines up perfectly. The quality of the light is slightly harder; you need darker sunglasses. Everything feels bigger. The pace is slower. On the side of the highways are large clumps of wild white lilies. The sunsets over the ocean are ethereal and lingering.

I'm driving the long flat highway to Margaret River, three hours south of Perth, to visit Karri Loam. It's the name of a new rammed earth house owned and designed by interior architect Miranda Geiger and her boyfriend, architect Ash Stucken of Studio Stooks. They met while working at the firm of Kerry Hill, an influential Western Australian architect, who designed many of the renowned Aman hotels in Asia.

Ash grew up in Margaret River, back when it was a quaint surf town off the beaten track, not a major destination for the tourism industry. Miranda was born in Jakarta but grew up in Borneo. 'My dad is a geologist,' she says. 'I grew up in a pretty remote rainforest area; it had one of the only populations of orangutans around.' The couple live in Fremantle and stay at Karri Loam when it is not rented out.

There has been a long tradition of cement-stabilised rammed earth houses built in Margaret River. With this build, cement was mixed with karri loam – the fertile, deep red earth of the local eucalyptus forest. 'We experimented with the colour until we were happy,' says Miranda. Luckily there was a spare lot next to the building site, where the formwork could be laid for the compacted mixture. After Karri Loam was finished, the two local builders were offered a job in Bhutan, to build a rammed earth Aman hotel.

'We wanted that handmade process throughout the house,' says Miranda. Going local was a huge part of it – the timbers and the trades. 'The rammed earth was the driving material and then everything had to complement but not overshadow it,' explains Miranda. 'It didn't feel right to have a flat wall paint. So we used limewash from the Western Australian company Bauwerk Colour. It's a natural, non-toxic paint that just softens the space. All the harsh corners became really calming.'

Early one morning while staying at Karri Loam, I visit the nearby Injidup Natural Spa – a fabled rockpool where the waves crash in from the Indian Ocean. It's dreamy, deserted. You could transport Karri Loam here and it would feel like it had grown out of the landscape. This is a new way of connecting to the coastline: the soft earthy pink tones of the house relate to the colours in the smooth, sculpted rocks by the sea, weathered by the tides and the winds.

Miranda and Ash cite Studio KO as an architectural influence, as well as the Western Australian firm MORQ. 'Immersive spaces, really about dark and light. Very much about one material. I'd say a little bit brutal in a way,' says Miranda. I understand what she is referring to – there is a brutalist element to Karri Loam – yet it's softened by the minimal but elegant furnishings. Sitting on the balcony, looking out to the karri forest, a few parrots come to pay a visit. It is a peaceful contemplative space.

Karri Loam is mostly used as a rental. Could you live in this simple, pared back way full-time, I wonder. 'I think we'd like to think we could live like this,' says Miranda, with a smile. 'Like not being with so much stuff. But I think that's a luxury for us, for anyone, living in a minimal house.'

'We didn't want to furnish it right away. We wanted to slowly collect things that we really loved – MCM House sofas. Armadillo Rugs. Cisco and the Sun cups.'

MALIBU
CALIFORNIA

A few years ago, when I drove out to Malibu, I saw a young woman dancing naked on the median strip.

It happened very quickly; I was driving fast, and it was a 'what was that?' moment before she receded in the rear-view mirror.

Another image. An older man, close-cropped military style salt-and-pepper hair, telling some surprised people they were not allowed to park beside the road. It didn't matter that there were no signs or street markings telling you not to park, he was a local and announced the fact with authority. When challenged by a younger man he doubled down. I got the sense he patrolled that strip regularly.

There's a Malibu of dreams. You read about it in books, listen to it in songs. But it's not actually one single beach, it's technically a city along a stretch of coastline. It's a place of natural disasters: mudslides, fires. Of privacy and luxury. It's hard to find the centre – it's more of a mood. An actress friend told me she feels her shoulders relax when she heads out to Malibu from Los Angeles; it happens just past the Getty Villa.

In the mountains behind Malibu is the spectacular Malibu Creek State Park. Then there's Topanga Canyon on the border of Malibu, home to many musicians and actors. A morning hiking in the hills through the coastal sage and chaparral feels rustic and remote. Later, a sumptuous dinner at Inn of the Seventh Ray, nestled along a creek, sitting outdoors under a canopy of fairy lights.

The Surfrider Hotel delivers another experience steeped in the Malibu essence: a rooftop bar, with comfortable sofas gathered around a firepit, and a view out to the Malibu Pier. You are elevated up above all the cars and the busy highway, floating away into that famous ocean sunset.

GREG CHAIT

MALIBU, CALIFORNIA

Something of a secret history hovers over the Paradise Cove trailer park in Malibu.

There have been articles about it in *The New York Times* and *Vanity Fair*, pieces on the movie stars who have lived there. A contradiction in terms – the humbleness of a trailer park within the luxury of Malibu. To get there you turn off the Pacific Coast Highway and head down a winding road. To your left, the most gorgeous beaches in Malibu. To your right, a boom gate, entry to the trailer park.

I've come here to visit Greg Chait, founder of The Elder Statesman, who lives here most of the time with his teenage daughter Dorothy. The Elder Statesman is a unique entity, crafting sweaters, cardigans, cushions and blankets knitted or woven in the finest quality cashmere yarns. An investment in price, sure, but something you will treasure your whole life.

It doesn't look like a trailer park. It could be a studio backlot. The 276 trailers are parked on an angle, more like little cottages with cactus gardens and balconies. Greg is welcoming and warm. I'd met him earlier, at his other universe: The Elder Statesman headquarters in Downtown Los Angeles where nearly everything is produced. It was like a creative village, a Willy Wonka factory. A room of deliciously coloured yarns. Artisans knitting on hand-powered machines, others dyeing clothes in vats.

Greg takes me on a tour of Paradise Cove in his golf cart, telling me about the people who live here. 'There are actors, lifeguards, firefighters, tech people, construction guys, architects, writers, producers, a lot of interior designers.' The individuals we meet along the way are relaxed and unpretentious. We go past a playground shaded by eucalypts – it feels safe and peaceful.

'You come in here and it's just total decompression. And simple,' says Greg. 'I mean, it's so easy. And that's something really special.' We head back to his trailer, which is small and compact. There's an outdoor eating area above the creek that runs down to the ocean, surfboards, plants, a sound system. There are The Elder Statesman cushions and blankets with that unmistakable handmade glow.

It's a lovely mood – cosy and light. 'Well, it's how much time you get to spend with something. Old houses can have soul because they have been lived in but new giant houses – it is very hard to get it right. Some people do – but it's the exception to the rule, 'cause it's interacting with something that creates the energy in the room.'

Greg's pathway to creating The Elder Statesman threaded through the spheres of Los Angeles and entertainment. His first job, when he was 18, was working as an intern for Whitney Houston. 'I met the person with the greatest aura of all time, and the most talent, first. Nothing else really intimidated me, so I was able to move freely in that world.'

He spent time in Australia and worked with the clothing brand Tsubi, taking it to the United States. He describes that period as 'a crazy moment in time. More of a movement than a business'. Another formative influence was his then girlfriend, who was in the process of setting up her company The Row. 'I learned a lot from her,' he says. 'I was 27 and I'm like, oh my god, now I know what I like, and I want to make blankets!'

We walk down to the Paradise Cove pier. The last rays of the sun hit the dramatic rock formations. Large estates belonging to legendary names look down onto the water from the hills. The beach is not very crowded; you can imagine an earlier Paradise Cove – the one in the 1950s, when fishermen started parking their trailers by the ocean.

For Greg, it's the view from out in the surf that is important. 'I got here, and I looked from the ocean towards the land, and I went – this place makes so much sense.'

Greg's two worlds, Paradise Cove and The Elder Statesman, have a beautiful shape – something that is hard to pull off. I wonder if you get to such a unique edit when you know yourself well. He thinks about it. 'As I do more work on myself, things go warmer and more minimal,' he says. 'Life's chaos, but there is depth.'

'At The Elder Statesman, we'll give the colours, and the knitters can lay down the stripes however they like.

The stripes of each individual item make it one of a kind. But it's still part of the same world.'

'One of the things I like about this house is that this type of living is also responsible. It's a trailer; it's got a lot of soul. A lot of fun. It's cool to live way within your means.'

MINIMAL COASTAL 141

142 NEW COASTAL

MINIMAL COASTAL 143

Above: The mini silver trailer at the entry to Paradise Cove **Right:** The Elder Statesman mushroom cushion

MINIMAL COASTAL 145

'LATE, BY MYSELF, IN THE BOAT OF MYSELF, NO LIGHT AND
NO LAND ANYWHERE, CLOUDCOVER THICK. I TRY TO STAY
JUST ABOVE THE SURFACE, YET I'M ALREADY
UNDER AND LIVING WITH THE OCEAN.'
Rumi

ISLAND
COASTAL

Dreams surround islands
A prison to escape from
Or a heavenly retreat
Wild, windswept and barren
Or secret and enchanted

KING ISLAND

TASMANIA • EROBIN

Traditional Owners and continuing Custodians: *palawa people*

Walking across the tarmac to a small propeller plane feels like an adventure.

Something Old World about it – shades of the last scene in *Casablanca*.

I'm heading over to King Island, off the coast of Tasmania, famous for its creamy and delicious cheese. The island is in the path of the Roaring Forties, winds that sweep the oceans of the Southern Hemisphere – spraying the island pastures with seawater. Cows grazing on this salty grass produce an unusually rich, sweet milk.

The local woman at the rental car booth at the island's airport has noticeably clear and bright skin. I wonder if it is to do with King Island having some of the cleanest air in the world. I'm reminded of Leslie Kenton, the beauty writer, who noticed her skin had never looked better than when she returned from a Nepalese mountain retreat where she couldn't wash it. She decided to continue not washing it as an experiment. But in London it didn't work – it was the fresh air that had given the radiance to her skin.

I drive out of the airport into the green fields – golf courses and paddocks give the island an orderly look. The cows look happy. Lines of grizzled trees in Doctor Seuss–like shapes border the pastures, forming windbreaks. Banks of trees have been cultivated around the houses too, protecting them from the strong westerlies. To get to my accommodation, Shore House, you have to drive through the King Island Dairy.

Shore House has a modern Scandinavian influence. The view is the thing and it's a sweeping one – out over the pale waving grasses to a vast waterscape. The light is mercurial. It feels like looking out onto a Turner painting. There's a sandy path down to the beach, which the occasional wallaby crosses. Shortly after I arrive there's a knock at the door and a woman from a neighbouring farm drops off a basket of supplies. Milk in an unmarked glass bottle, presumably straight from the cow. Freshly baked bread. Homemade yoghurt, cookies and apple sauce.

Apart from a vintage cream Mercedes elegantly cruising through the fields, the roads are mostly full of working vehicles. A lot of them have unusually shaped trailers that I come to recognise as kelp haulers – the other big industry here. The kelpers gather seaweed washed up on the beaches and deliver it to the processing plant. It's dried out, then crushed into granules and much of it shipped to Scotland. The alginates extracted are used in products like ice cream, salad dressing, toothpaste, paint – the list goes into the thousands.

I visit the 'Restaurant with No Food', a charming, much-loved little boathouse set up by local artist Caroline Kininmonth. She has decorated it with hanging fishing nets, a piano, colourful tables and chairs. It looks like a restaurant, and it's open to the public, but supplying the food is up to you. 'You can go there with a book, a bottle of champagne or a hamper with cheese and crayfish,' says Caroline. While I am there, three people turn up with a birthday cake.

There are no roaring winds during my stay. It feels calm and peaceful looking out from the deck of Shore House. But the still waters are deceptive; the seas are treacherous around King Island. There have been more than sixty known shipwrecks, involving the loss of over one thousand lives. Many King Islanders are descendants of shipwreck survivors.

On the morning of departure, I drive back to the airport. A man on his lawnmower waves. There are cows grazing next to the runway. I feel refreshed. More than that – a sense of uplift and wellbeing. I think it might be the air.

1. View from a bedroom in Shore House
2. Street in the main town of Currie
3. Kelp drying on racks
Overleaf: The view from the sauna at Shore House

3.

2.

ROTTNEST ISLAND

WESTERN AUSTRALIA • WADJEMUP

Traditional Owners and continuing Custodians: Whadjuk people of the Noongar Nation

Visiting a new place, you usually have a few fragments to go on. There's the name and what it conjures up. A couple of photos.

Some information on the internet which tells you lots of history and facts but nothing really about the actual experience of being there.

I'd always found the name Rottnest Island off-putting – it sounds guttural and harsh. The nickname 'Rotto' – not much better. All confirmed by the translation behind the name: Rats' Nest Island. It was given the name by a Dutch captain in 1696 who mistook the native quokkas for giant rats.

But then I saw a photo of the new Samphire resort. It was the most powerful kind of photograph – one that makes you want to be there. It was of a casual beach bar set up on the sand overlooking the water, with comfortable-looking chairs, fairy lights and firepits. It looked like something you would find on a Greek island.

Samphire itself is a beautiful-sounding word: it calls to mind jewel-like images. It is a name given to several succulent salt-tolerant plants found in coastal areas. Originally 'sampiere', a corruption of the French 'Saint Pierre', it was named after the patron saint of fishermen, Saint Peter. Indigenous Australians have long used native samphire species as bush tucker.

You see a lot of photos of quokkas in Western Australia, always the same angle – a quokka looking quizzically up into the barrel of the camera. Distorted, with a big head. Seeing them appear in the indoor bar at Samphire was completely different. They are beguiling creatures, friendly and inquisitive. They like to say hello and hop over like gentle little wallabies.

ISLAND COASTAL

The quokkas set the tone on Rottnest. It's relaxing to take off your shoes and walk along the sands in the strong sea breeze. There are hardly any cars but lots of bikes. If I lived in Perth, I would come here all the time. It's rare to have an island experience so close to a city.

There's a dark shadow to this light. For nearly a century Rottnest Island was a prison, then a forced labour camp for Indigenous men and boys. Many escapes were attempted. This past seems closer walking through the buildings on the island in the early morning quiet.

In the evening I sit in the sandy Samphire bar. It's exactly like the photo. I meet a young couple who have been travelling around the top end of Australia in a van with their small children. Their faces are glowing with the adventure of it all: the colours, the wild and raw beauty. Now they had a night to themselves, and I see them holding hands near the firepit, looking out as the sunset lit up the sky. Just pure experience. Nothing to do with words or photos.

1.

2.

1. A gentle, friendly quokka
2. The tiny Rottnest Chapel
Opposite: The beach bar at Samphire

MAINE
UNITED STATES OF AMERICA

I arrived in Maine on a misty morning when the leaves of the trees were turning yellow and red. Everywhere was lovely. It was like I had shrunk down and was driving through an elaborate toy train set.

The architecture was uniform with plain simple lines. There were lighthouses and lobster shacks. Colourful little buoys and anchors strung up as decoration on roadside buildings.

At the airport, most of the rental cars were gone and I had been offered a choice between a minivan and a Dodge Challenger, an unfamiliar name to Australian ears. I'd taken the bright red Challenger and was now driving down the freeway in a muscle car. Most of the other cars seemed to be pickup trucks in muted colours. It felt unusual but fun, like trying on another personality. What actors must experience with different roles.

After stopping off in Portland to get supplies, I continued on to Bailey Island, just under an hour away. Surprisingly, Maine has a longer coastline than California when you combine all the tidal inlets and the over three thousand islands. Geologists call it a 'drowned coast' – where an ancient rising sea level has covered former land features, creating bays out of valleys and islands out of mountain tops.

I was to be based on Bailey Island for a few days, staying at Jaquish Cottage, which is part of Carter Smith's The Gills Group. From the start, I felt completely at home. Sitting in a swing seat looking out over the sea view at sunrise, there's a honey gold quality to the light. You can see why Maine was called the Dawnland by the Indigenous Wabanaki people.

I soon form a routine driving off Bailey Island into the town of Brunswick and getting a morning coffee from Dog Bar Jim, a cafe in a rickety narrow old cottage. It's filled with students and academics from nearby Bowdoin College. There's hessian covering the fluorescent lights, creaky wooden floorboards, and Roy Orbison and Elvis playing on the stereo.

ISLAND COASTAL 159

Brunswick's Main Street feels like classic small-town Americana, with the contemporary touch of a shaman CBD shop. An old man sweeping the pavement outside his shop has a friendly greeting: 'You have yourself a good day, darlin'.' The antique market at Fort Andross is a place where you could fossick for days.

I drive to the nearby Shelter Institute which runs a three-and-a-half-week course on how to build a house – a mix of framing and physics. People come from all around the world. Meeting Pat Hennin, the founder, he tells me how he built his own solar house in 1973. When *The New York Times* ran a feature on it, he received over 30,000 letters from people asking him to build them a house. He said he could teach them instead and has been at it ever since. An innovative thinker, his latest project is a plan for a new form of active retirement home.

On the weekend I head further up the coast in the Dodge Challenger. John Cougar Mellencamp's 'Jack and Diane' comes on the radio – I turn it up. It's good driving music. It's easy to get around in Maine – the freeways are clearly marked. The number plates on the cars say 'Vacationland'.

In Rockland I visit the Farnsworth Art Museum and see the work of famous Maine painters – three generations of the Wyeth family and Alex Katz. I browse through the bookstores – as in most small towns in Maine, there are a lot of them – and follow it with a wonderful dinner at Sammy Deluxe. The next day I walk to an unusual lighthouse down the end of a long chunky stone seawall, guarded by a group of barking seals on nearby rocks.

Driving back down to Portland, I turn off the road to visit the Glidden Point Oyster Farm. It's down a dirt track – a barn with some outdoor seating under amber-coloured trees. There's a smoky haze in the air and lazy music drifting. Glimpses of water shine through the trees, beyond some men building a wooden bridge. Small groups of people wander down to see the oysters in the cages under the dock. If the scene were a painting, I'd hang it on the wall and always think of Maine.

1. Gulf of Maine Books, Brunswick
2. View from The Gills cottage on Bailey Island
Opposite: Glen's Lobsters, Bailey Island

CARTER BEDLOE SMITH

BAILEY ISLAND, MAINE

'I had to leave Maine to fall in love with Maine,' says Carter Bedloe Smith.

He took off from his home in Bailey Island at seventeen, headed for the energy and opportunity of New York City. 'I ran with it for fifteen years,' he says. 'I went hard and fast, did amazing jobs with incredible clients and travelled all over the world.' His career trajectory started out in magazines; he went on to photograph many well-known celebrities. Now he is directing independent films.

I wondered what drew him back, and he says it happened when he heard two special cottages in Bailey Island were up for sale. 'I'd always been like if it was ever a *remote* possibility then I would bend over backwards and do anything to get them.'

We are sitting on the generous deck of one of them now, looking down over a sweep of ocean, a small island with a single house in the distance. It's a stormy, squally day which lends the conversation a certain intensity. I ask him about the four cottages he now owns and rents out on the island. Carter is here for a few weeks, for a break and creative recharge from his busy life in Brooklyn and Los Angeles. 'One of the things that's so interesting about Maine is that there's always been craftsmanship here,' he says. 'Starting with the Native Americans and through to boatbuilding and industries like fishing. The quality of the air, the beauty and the light have always attracted writers and painters. And there's an interesting balance between creative types and craftsman types and working-class types. You don't get that in a lot of other places.'

The island has its own kind of enchantment. Small bays dotted with boats. Waves crashing on rocks. Little cottages in the forests. An ethereal edge. The psychoanalyst Carl Jung spent several summers here in the 1930s. Carter sees the beauty all year round: 'When it is snowing – the sunrise is *just* as beautiful in the winter. I've sat by the fire in one of the cottages and watched a family of foxes run across fresh snow. Stuff that just doesn't happen in your normal life.'

Carter's cottages feel cosy and welcoming, framing the views of this fierce and lovely coastline. The mood he has created seems to have distilled some essence of Maine. Each cottage has a set of Hardy Boys, Nancy Drew and Stephen King books, and a copy of the book *Jaws*.

The designer Charles Eames once said, 'The role of the designer is that of a very good, thoughtful host, anticipating the needs of his guests.' For Carter the experience is very much about people connecting.

'I think that Maine is best when you are not rushing around to do stuff. Pick up some lobsters and grill them in front of the ocean and drink wine on the lawn. Eat lobsters and not worry about what to do. There's plenty of great restaurants and there's plenty of great shopping. But what I find is people come with big plans and then they never leave the house, and they never leave the property. And that makes me so happy to hear that.'

Part of the power of Maine's beauty lies in its wildness. It's getting darker out, the wind is rising. Carter and I move into the living room. We are high up above the ocean; it almost feels like we are in a lighthouse. He tells me of an incident several years ago. 'I got a message from my parents – there had been a rogue wave, which is a single wave, that came up and hit this house,' he says. 'Blew these windows in – there were shards of glass in the sofa. Luckily this house is over a hundred years old and not airtight. All the water just drained right out. But it was a wave that hit the house. Just as a reminder. Like OK … the ocean was here first, I need to be respectful and understand my place in this.'

'Because of my background in photography, I often think in little tableaus – a desk, with a vintage typewriter, some paper.'

ISLAND COASTAL 165

'In all my houses there's one big communal space, including the kitchen and dining area. But then there are little corners and nooks to do puzzles and read books.'

168 NEW COASTAL

'A SHIP IN HARBOUR IS SAFE,
BUT THAT IS NOT WHAT SHIPS ARE FOR.'
John A Shedd

PANORAMIC COASTAL

The sound of waves,
crashing and receding
Wide open views
The far horizon of possibility
Vast dark waters at night

PALM BEACH & AVALON

NEW SOUTH WALES · GURINGAI COUNTRY

Traditional Owners and continuing Custodians: Garigal/Caregal people

It used to be illegal to swim on beaches in Sydney: it was considered a dangerous, even immoral act.

There was an 'Inspector of Nuisances' on hand to enforce the ban, although plenty of people found ways around it. After a relaxation of rules in 1902, interest in areas by the coast increased.

In the early days of Palm Beach, you had to come by boat, along Pittwater. The local builders, father and son team Albert and Fred Verrills, would unload materials from the jetty and haul them to site on a horse-drawn cart. The houses had wide verandahs, walls of rough-cut sandstone; and the timber was painted charcoal black. They were lit by hurricane lamps and given romantic names – Kalua, Summerlands, Back O'Moon, Mandalay.

Today it takes around an hour to drive to Palm Beach from Sydney. It still has a different feel – lusher, more tropical. Bare rockfaces and ledges lead to pockets of cycads, orchids and ferns. Unusually for a coastal suburb close to a city, there's a lack of high-rise buildings.

What Malibu is to Los Angeles, Palm Beach is to Sydney. There's an accessibility for visitors though, areas of parkland in the deep shade of Norfolk Island pines. The local council have installed gas barbeques and seating – large groups of families and friends can set up for the day. Across the water is a national park and a camping ground near a lagoon.

The holiday rental Lilypad is a new way to experience Palm Beach. It's a perfect little house, floating on the water, with Scandinavian-inspired design. Everything inside feels clean and fresh. There's a bench where you can sit and eat looking out at the view. A fireplace with a gas flame. The little house turns and floats on the mooring, changing the view through the windows.

The nearby village of Avalon is currently seeing a resurgence. You could buy a beautiful wardrobe of clothing between Bassike, Lee Mathews, Mamapapa and The Hunted. There's the Hungry Ghost laneway coffee and the Classic Coffee truck on Avalon Headland which appears in the morning. Beachwood has a wonderful array of homewares. There's Bar Elvina and the French restaurant Bistro Boulevard.

There's nearly always a film crew in Palm Beach. The popular soap opera series *Home and Away* has been filming here for over thirty years. The town in the show, Summer Bay, is an abstract kind of a place. People are either at the surf club or in the cafe or on the beach. Never a banal shot of a post office, bank or traffic lights. It was an inspiration for the town of Seahaven in the movie *The Truman Show*.

1.

1. Firepit by Hortology Gardens
2. The Palm Beach lighthouse
3. Cabin of the artist Bruce Goold

2.

3.

Lilypad Palm Beach

SUSAN ROTHWELL
PALM BEACH, NEW SOUTH WALES

Entering Susan Rothwell's Palm Beach house is like a knockout punch.

The large windows frame a panoramic view of mesmerising beauty.

It's what a bird would see flying over the coast – the beach, the headlands, Lion Island and the river system. Susan is an architect and designed the house: there is large stone flagging on the floor, like something out of a temple, and sandstone columns framing the view. But it didn't start out like this. It started out in a red Kombi van going round Scotland in the wet and cold winter of 1969.

Susan and her husband Garry were young graduates on a long-haul overseas trip. Importing antiques back to Australia wasn't a thing then, but they had some knowledge of the market. 'We were looking at it very commercially,' says Susan. 'Buy these candlesticks for 15 pounds and sell them in Australia for the equivalent of 70 pounds. Chairs, mirrors and silver. The bigger things we'd put on the roof of the Kombi, covered with tarpaulins.

'We used to sleep in the Kombi as well,' she recalls. 'One night, we had all these candelabra going and our tins of baked beans for dinner and there's a little knock on the window. A policeman looks in and says, "Hello, hello, hello what have we got here?"' Garry and Susan had to get out all the receipts to prove they were legitimate.

Back in Australia, they exhibited the antiques in garages. The money they raised set them up to buy their first apartment. It was the start of an expansive life together: Garry working as a property developer, Susan as an architect. They have three children and eleven grandchildren. Painting is another of Susan's passions: 'It's my time out, like meditation.'

I've known Susan a long time and there's something about her that reminds me of Katharine Hepburn. Not just her physical appearance, her bone structure, but a certain insouciance. She makes things seem effortless. A going-forward energy.

In the 1980s, while maintaining her architectural practice, she studied for an advanced certificate in horticulture. 'For me the garden and the building are one,' she says. Going deeper into the idea of walled gardens and outdoor living she has made several

trips to the Near East, travelling in Syria, Jordan and Iran, across the Tigris and Euphrates rivers, visiting the site of the ancient Hanging Gardens of Babylon. Something she appreciates about design in that region is 'the connection to nature in everyday life. Even taps – they make them look like lotus flowers, which actually gives people joy when they use them'.

One of Susan and Garry's current projects is the renovation of an old olive oil soap factory on the Greek Island of Paxos – they are turning it into a boutique hotel. 'We bought a funny old boat thirty-five years ago in Europe,' she says. 'We'd just go pottering around the Mediterranean at a very slow pace in the summer.' In Paxos, they spotted the series of stone buildings with the distinctive big brick chimney. Thirty years later there was a 'for sale' sign outside ...

Susan has been working with an onsite architect who specialises in hotel design and an archaeologist who works with the Greek government. The only way to get to Paxos is by boat. 'You can have breakfast and walk through the olive groves. Just enjoy Paxos life. Swim in the sea – it's a crystal-clear turquoise.'

I ask Susan where she gets her energy from. 'I don't think I'm very different from other people,' she says. 'I've just got a lot of things that I love doing. I certainly don't have any energy at all for tidying cupboards or cleaning out drawers ... so those things are totally neglected!'

'The thing about coastal design is the houses need to be flexible as they are often a holiday destination. So, you have a side table the same height as the main table – you can add them together. A table that seats twelve can then seat twenty-four.'

PANORAMIC COASTAL 185

TIPS ON *DESIGN* AND *COASTAL* LIFE

I'm always interested in hearing advice
from people at the top of their game.
I asked several stylists, designers and
architects about their favourite things.

Tom Kundig

American architect Tom Kundig is the principal and founder of Seattle-based firm Olson Kundig. His work includes the iconic and poetic designs of Studio House, Chicken Point Cabin and The Pierre. He has received many of the design world's highest honours.

Interiors advice?
Keep it simple and clean. Instead of filling up spaces with stuff, use special items and important artefacts. Always relate to the exterior so there's a seamless interior–exterior relationship. Interiors should be about refuge, and comfortable furniture helps create that feeling.

Way to stay creative and focused?
I'm not sure being creative always means being focused. Sometimes being creative is being open and curious about what's around, gathering new information. As you glean more of that, I think you're naturally going to be more creative.

Guiding motto on tough projects?
Tough projects usually lead to better projects. When the stakes are tough, the creativity really ramps up.

Coastal landscape?
Coastal landscapes are challenging and fantastic, which is one reason we're attracted to them.

Way to light a room?
As softly as possible, so that it glows rather than being bright. You don't want to see the source of light. Instead, it should seem almost like there is no light and yet the room is lit.

Magical house you have visited?
Albert Frey's house in Palm Springs has always been a magical house in the landscape.

Materials to use in structures on the coast?
Materials have to be tough and robust and able to embrace the natural weathering process. Materials that get better with time as they adjust to a challenging environment.

Place for inspiration online?
Personally, I have a hard time seeking inspiration online, but as a source of information, online is pretty interesting.

Way to achieve coastal ambience?
Coastal ambience comes partly from colour, partly from opening to nature and letting the outside come inside, as well as extending the interior outside.

Coastal holiday?
I like to have a very relaxed holiday. The coast is all about that mesmerising, peaceful, meditative – and sometimes stormy – experience and the ability to connect with the interesting forces and vibrations of the world.

Leanne Ford

Interior designer Leanne Ford's formula is 'Texture + Vintage + Nature + Books + Art = Soul'. Well known for her renovation shows – *Restored by the Fords* among others – Leanne has designed furniture collections for Crate & Barrel and created the inspirational art and home magazine *Feel Free*.

Small pleasures?
I love my bath time, it's where I get my best thinking done, and I love a road trip with good music.

Interiors advice?
Make what you have beautiful now, don't sit around and wait for a new house or a new addition or a new decorator. Work with what you have now to create a space you love.

Clothes to wear by the sea?
A simple black one-piece with an A-line skirt as a cover-up. I always like to have a pair of cool sunglasses.

Things to bring a room to life?
Friends, music, martinis and art.

Way to stay creative and focused?
For me, it is to understand when my brain can focus and when it can't, then from there I like to schedule my calendar accordingly. This way I am never forcing myself to be creative when I am not in the mood.

Guiding motto on tough projects?
Stay true to your original vision; don't give up now!

Classic coffee table book?
Allure by Diana Vreeland, *Monochrome Home* by Hilary Robertson and *The Lyrics* by Bob Dylan. I also love lying art flat on a coffee table in lieu of the typical book on a coffee table.

Coastal colour palette?
Creams, whites and natural bleached-out woods.

Small businesses you like to buy from and support?
Imprint House.

Place for inspiration online?
Old rock'n'roll documentaries.

Coastal motif?
I love bleached driftwoods and I am a sucker for collecting shells and beautiful rocks. I just let them sit on the table among other pretty things.

Way to shop?
I tend to buy what I like when I see it, knowing it will always find a home.

Budget design saving?
A can of white paint – it can turn anything into anything.

Mood by the sea?
All by myself, with a book and a pencil.

Sean Moran

Sean Moran is the chef and owner of one of Sydney's most treasured restaurants, Sean's Bondi. A meal there is a warm and welcoming experience, soulful cooking with an ocean view. He is also a practitioner of shellcraft.

Interiors advice?
As much handmade charm as possible.

Hideaway by the beach?
Lobster Cottage, Sawtell, a vintage beach rental shack on the estuary.

Things to bring a room to life?
Anything in season – from locally picked flowers, branches of foliage or bowls of fruit or vegetables. A blemish, a bit of ripped stalk or leaf; imperfect = perfect.

Way to stay creative and focused?
I wish I knew!

Magical house you have visited?
My dear friend Nici Long of Cave Urban is an incredible sustainable architect and recently downsized her family home to a cubby in the garden. Her pebble-dashed kidney-shaped pool is now transformed into a magical living space.

Coastal colour palette?
Depends on the architecture. Mixed stripes of any colours always feel like a holiday. In my restaurant in Bondi, I find calamine pink flattering. I'm painting our house up in the Northern Rivers in an uplifting yellow; trouble is, I'm planning to stick all my saved buckets of scallop shells over it.

Small businesses you like to buy from and support?
Grandiflora, the Bay Tree, Chef's Warehouse, Velluti's fruit and veg, Joto Fresh Fish, Iggy's Bread, The Little Marionette, The Society Inc.

Place for inspiration online?
Gumtree and auctions – anywhere that someone is selling old stuff.

Up-and-comer in the design world?
Corey Ashford.

Coastal motif?
Shells (particularly ones that come off people's plates).

Way to shop: spontaneously or a more planned approach?
A bit of both – spontaneity is definitely more fun.

Design splurge?
A vintage cane palm tree lamp with coconut lights we bought online at auction. One other mysterious buyer was equally smitten – so we paid way too much!

Design saving?
Large wholesale egg cartons make perfect serving platters for freshly shucked oysters – and no washing up.

Mood by the sea?
Like I belong.

Patrick Kennedy

Patrick Kennedy is a founding partner of the award-winning Melbourne architectural practice Kennedy Nolan. As well as his involvement in projects, from the early design details to the built work, he leads the firm's design direction – towards a handmade, handcrafted, sculptural form of modernism.

Small pleasures?
Walking my dog.

Interiors advice?
Don't look sideways – focus on what feels right for you.

Beach bag or weekend bag?
I'm too uptight to travel with a beach bag, unfortunately.

Clothes to wear by the sea?
Orlebar Brown bathers because they go from beach to bar.

Things to bring a room to life?
Relaxed, comfortable, happy people. And dogs.

Ways to stay creative and focused?
Travel, new experiences, being in the world.

Guiding motto on tough projects?
Work out the why and the how, and the what will follow.

Way to light a room?
Just make sure that light isn't too even, too cool and too bright.

Magical house you have visited?
The Walsh Street house of Robin and Patricia Boyd – experimental, theatrical, hospitable, intensely domestic.

Coastal colour palette?
There are no limits to colour at the coast or anywhere.

Small businesses you like to buy from and support?
I love Cibi, a local Japanese cafe and shop.

Place for inspiration online?
Not a big online browser.

Coastal holiday?
Just returned from the Coromandel Peninsula in New Zealand – perfect place for a beach holiday. Pristine environment, flawless beaches, warm water and friendly Kiwis.

Ways to bring festivity and abundance to decorating a table?
I like to use the most beautiful version of everything to hand – linen, cutlery, plates and bowls, salt and pepper grinders, whatever is needed or within reach. And if possible, serving the food at the table from large platters or cooking dishes.

Way to shop?
We all need to shop less.

Design splurge and design saving?
Fewer, better things – seems to balance things out.

Mood by the sea?
Reflective, calm.

Jason Grant

Organic, natural, and coastal – stylist, interior designer and author Jason Grant embodies these principles in life and design. He is the author of *A Place Called Home*, *Away at Home* and *Modern Retro Home*. He lives in a warehouse by the sea in Byron Bay.

Small pleasures?
Sleeping in, sunsets and sunrises, lighthouse walks. Morning coffee, walking my dog. I love to elevate the everyday. Life for me is all about simple pleasures.

Interiors advice?
Be yourself. It is always best to look inwards not outwards. It took me a while to understand that my style is a culmination of all the things I love.

Hotel by the beach?
The Blue Water Motel Kingscliff (I designed it), The Atlantic Byron Bay.

Weekend bag?
I do love/prefer a basket. Wandering Sol, Olli Ella, and classic market baskets. Perhaps it's all those years as a magazine stylist, lugging props in baskets.

Coastal clothes?
I have the 'less is more' approach to my wardrobe – a few favourites on high rotation. Heading to the beach the option is always for ease and comfort. Jac + Jack, Bassike, Mr Vintage, Ghostwood Vintage, Saturdays NYC. Local Supply sunglasses – made from plant resin not plastic.

Things to bring a room to life?
Lighting. Personal touches. Colour palette.

Way to stay creative and focused?
I think distraction is part of the process. Everything comes in waves, especially creativity. I work hard and am focused but I rest hard and secretly love to 'vague out'.

Guiding motto on tough projects?
Consistency. I try to enjoy my work as much as possible and am discerning about projects and clients. I am always a realist and an optimist.

Way to light a room?
Never from overhead.

Small businesses you like to buy from and support?
Mud Australia and Dinosaur Designs bring unique Australian design to the world.

Up-and-comer in the design world?
Spencer Ceramics – I love the brutalist implication in his artisan everyday wares.

Coastal colour palette?
Blue and green. I consider most shades of green a neutral.

Mood by the sea?
Simplicity and calm.

Hilary Robertson

Hilary Robertson is the author of seven books, including the recent *Nomad at Home*. An interiors expert, she has styled shoots for Crate & Barrel and West Elm. Along with Leanne Ford, she is the co-founder of the print magazine *Feel Free*.

Interiors advice?
Buy local! I like to build a home from a local network of makers, flea markets and auctions. Pieces that I have stumbled across. I like the feeling of connection to my neighbourhood. An interior put together organically feels more personal and idiosyncratic. There are more stories in rooms like these.

Hotel by the beach?
Any beach shack hotel in Tulum in Mexico. Or somewhere more traditional like the Grand Hotel des Bains and Spa in Locquirec, Brittany; or Gio Ponti's Parque de Principi in Sorrento, Italy.

Guiding motto on tough projects?
Bird by bird.

Classic coffee table book that has inspired you along the path?
The Way We Live: By the Sea, Stafford Cliff.

Way to light a room?
Lots of lamps in different shapes, supplemented by Noguchi paper hanging lanterns.

Magical house you have visited?
So many, but Maxime de la Falaise's house in St Rémy de Provence was magical and deeply comfortable.

Coastal colour palette?
Giorgio Morandi tertiary colours reflecting the landscape and seascape.

Small businesses you like to buy from and support?
Of The Cloth.

Place for inspiration online?
Pinterest, the Criterion Film app and Bukowskis auctioneers.

Coastal holiday?
Greek islands, where I can swim in the Aegean.

Up-and-comer in the design world?
Max Lamb.

Coastal motif?
Anchor – particularly the Camargue Cross, a hybrid of heart, anchor and cross.

Preferred way to shop?
I like to buy when travelling but I plan by keeping loads of mood boards, and I often stumble across equivalents. When I have something in mind, I manifest it!

Design splurge and design saving?
I will always splurge on a sofa, lighting, sculpture, paintings. But I am an inveterate bargain hunter so I will always look for a vintage piece above anything new.

Mood by the sea?
Contemplative.

Room painted in Bauwerk Colour limewash 'Humming' – designed by Hans Blomquist.

Hans Blomquist

Internationally renowned stylist Hans Blomquist has worked for Ikea and Anthropologie, among many others. He is inspired by the natural world and his work carries a personal feel. He is author of *The Natural Home*, *In Detail*, *In the Mood for Colour* and *Inspired by Nature*.

Small pleasures?
Walking barefoot and not having to think of what to wear. That is coastal living to me.

Interiors advice?
I have recently bought a house on an island in Greece. The house will be kept white and the shutters blue. We will keep the old grey stone floors and the wooden beams in the ceiling. In very sunny climates I think it is important to add wood and warmer tones to calm the brightness down but still keep the very light and airy feeling. Natural materials are for me the only choice to go for. Wood, stone, linen, cotton. I would stay away from plastic in any shape or form when creating a coastal interior as it is a material that does not belong there at all.

Clothes to wear by the sea?
Lightweight, loose fit, linen that can get as wrinkled as it needs to. Flip-flops.

Way to light a room?
I always go for very soft, warm lighting. Mostly, the only light needed is real candles and one can never have too many. They are just as important in summer as in winter.

Guiding motto on tough projects?
Everything is possible and will be OK in the end.

Things to bring a room to life?
In a coastal interior I think everything that is found in nature will bring the interior to life. Driftwood sculptures can make the most eye-catching feature, big or small. Weathered linen textiles will add softness and texture. Soft linen curtains that move with the breeze from the sea are the most romantic thing in a coastal interior. It will feel like you always are in a great movie set.

Ways to bring festivity and abundance to decorating a table?
Candles and soft-wrinkled linen. White plain china and simple glassware.

Coastal colour palette?
White, blue, sand, driftwood, ochre, brown, warm grey.

Emily Ward

Emily Ward and her business partner Louisa Pierce create beguiling interiors filled with art and luscious textiles. Their shop Pierce & Ward in Los Feliz in Los Angeles is a place where you want to sink into a deep sofa and while away an afternoon.

Small pleasures?
Burning incense, having time to go for a walk, cleaning while listening to an audiobook, talking to my business partner Louisa for fun and not work.

Interiors advice?
Buy what you love, not what you think will fit best. It will look good wherever you end up placing it and you will enjoy it.

Beach bag or weekend bag?
Backpack!

Things to bring a room to life?
Art, kids, a record player.

Way to stay creative and focused?
When I'm not working, I like to collage while my kids are making art.

Guiding motto on tough projects?
This too shall pass (credit to Louisa).

Classic coffee table book?
Always William Eggleston, Lucian Freud, Alice Neel.

Way to light a room?
Lamps! Dimmers!

Beach holiday?
Our place in Northern California is by the beach and it's our slice of heaven.

Coastal colour palette?
Brown, camel, ivory and turmeric.

Small businesses you like to buy from and support?
I love so many but now that I am at our store a lot, I love the local places: New High Mart, Reckless Unicorn and Maru coffee shop.

Up-and-comer in the design world?
Rhett Baruch Design – he is a good friend and has the best eye for weird beauty.

Coastal motifs?
Seagrass, redwood, vintage lamps, layered blankets, cosy rooms with a fire in the morning and at night.

Way to shop: spontaneously or a more planned approach?
Spontaneously for sure! Always start with the big pieces: sofa, bed ... everything else can play off that and find a life anywhere.

Design splurge and design saving?
It's all about balancing high and low to achieve the undecorated feeling. I have chairs I spent my savings on and chairs that my parents found on the side of the road.

Mood by the sea?
Safe, patient, warm, without a care.

Above and overleaf: Emily Ward's house on the coast in Northern California.

TIPS ON DESIGN AND COASTAL LIFE

Sarah Andrews

Sarah Andrews is an interior designer and author of the books *Principles of Style* and *The Poetry of Spaces*. Her evocative coastal retreat in Tasmania, Captains Rest, is known around the world, and is a much sought after short-term rental.

Clothes to wear by the sea?
Bare feet, light cotton dresses and Celine sunglasses. I have a knitted bucket hat I take everywhere.

Things to bring a room to life?
Personal objects of affection. I like to have books filled with instant photos from special moments in my life. Various collected antique busts and bits of statue found on my travels to Europe. A single, simple, unscented table candle burning somewhere safely.

Ways to stay creative and focused?
I am still seeking the answer to this one, currently my motivation is deadline – but there must be a better way!

Guiding motto on tough projects?
I focus on what makes me happy and turn off the noise of the outside world. I find not sharing much until it's finished helps a lot.

Way to light a room?
Candlelight, shaded lamps or sconces with a warm, low-wattage bulb. As little as possible – shadows are so beautiful.

Small businesses you like to buy from and support?
Alepp Soap, Kalaurie Atelier, small forest shop, Metta Melbourne, Nunchi Oils, Southern Wild Co, Flynn Home Store, artist Monique Fedor, vintage wares from Scout & Bird, bedding from In the Sac, jewellery from Cleopatra's Bling and *Galah* magazine.

Coastal holiday?
Tasmania. So wild and free.

Up-and-comer in the design/makers world?
I adore ceramicist Kirsten Perry and wall artist Clare Scanlan from Scanlan & Makers.

Thing about living on the water?
I start every day with a cold swim no matter the season, and then I hop in a hot bath that overlooks my little cove. A small delight to start every day. Some days when the wind is howling and the rain is pouring, it's tough to do, but I never regret it!

HOW

TO

CREATE

IT

PLACES TO GATHER. PLACES TO WORK. PLACES TO REST.

I spent many years as a set and costume designer in film, theatre and television. Budgets were often tight, and time was of the essence. I learnt to identify the key props and design touches that would advance the story-line and create a specific mood.

In the following pages I've created ten styled set-ups using a range of coastal elements. Some spaces are in my own home, which is in the city, near the coast. Others are created in the coastal homes of friends – using things loaned from homewares companies, as well as from my personal collection.

I've used a three-colour palette as a starting point – a simple way of giving a space cohesion and calmness.

DESIGN *BY THE COAST*

Ask any interior designer about their key inspiration and they will often say nature.

The organic curving forms. The colour combinations – brilliant, bold and unexpected, or calm and soft. The textures – like the furry underside of a leaf. Even the dilapidated beauty in how things decay.

By the sea there is endless natural inspiration. The blues, greens and greys of the water, and the yellows of the sand and sun create the colour palette. A window to a view becomes the painting on a wall. Rattan, wicker and cane become the textures. Shells become lights. Driftwood becomes sculpture.

'Simplify and then add lightness' could be the motto of coastal design. Less things, less stuff, more space to move around in. Moments of translucence – hanging glass buoys, layers of watery limewash.

Then there's the power and fierceness of nature. Storms, winds, erosion. Weathered exteriors. There is a reason cosiness works by the coast. On an elemental level it is protection from the elements. Layers of cushions, textiles and throws create softness. A room glowing with pools of lamplight at night. A fire in the grate.

Looking out to the ocean. The crash of the waves, the sounds of the parrots or seabirds. The smell of salty air. The traces of sand through the house.

Coastal style always comes back to nature.

SOURCING

Sometimes when working on an interior design project, I fantasise about having an unlimited budget. But then, thinking it through, a room that is filled with very precious things could make you more self-conscious. There is something about being relaxed in a space.

It's good to buy from a variety of sources. When you buy everything from the same place all at once you get a showroom look. The most stylishly dressed people combine vintage, designer and new. It's all in the mix. A room is best created in layers, slowly.

This list is about sharing places where I personally like to shop – I don't have any paid sponsorship deals.

NEW
West Elm, Pottery Barn, Anthropologie, Ikea, HAY Furniture and Muji. Some things are better new, like mattresses and garden furniture. I always prefer to see things in real life, but if you have to buy online, the key is to double-check the return policy.

VINTAGE
Vintage and flea market shopping is such a pleasure – sometimes one unique piece can spark a whole room. My absolute favourite is the great Rose Bowl flea market in Los Angeles. Also in Los Angeles there's the Venice Flea Market and the Topanga Vintage Market. In Sydney, the Merchants Warehouse and The Powder Works. Online auctions can yield treasures too.

ETSY
Etsy is a modern version of a world market. My favourite stores are Best of Colombia, Lumio Studio in Poland, Naxosart in Greece, Zaarefolks in Ghana, the knottingshop in Turkey, Aurelia Boutique in Lithuania and OldWoodenStool in the Netherlands.

WELL CURATED STORES
These are stores created with real love. It's inspiring to see how the shop owners put it all together. The Society inc by Sibella Court, Pepperwhites by Tara Dennis, Alfresco Emporium and Beachwood in Sydney; Few & Far Co., tomolly, Suzie Anderson Home and The Evandale Village Store in regional Australia; Pierce & Ward in Los Angeles; Roman and Williams Guild and John Derian Company Inc. in New York City; The Post Supply in Maine.

TEXTILES
Beautiful textiles bring in softness, comfort and colour, making the room more inviting. For rugs, I go to IB Perryman in Sydney. For linen, Cultiver. Sally Campbell for cushions. Utopia Goods for unique Australian motifs.

ART
This is a vitally important layer – it brings in a spirited feel. Works from exhibitions. Artworks from friends. Finds from flea markets and auctions.

PERSONAL
The things you would save if there was a fire. Family heirlooms. Photographs. Something special found on a holiday, imbued with that memory.

At the end of the day, most things are just tools used to create the atmosphere that you want.

Coco Chanel was a great collector: beautiful intricate screens, golden sheaves of wheat, anything to do with lions (she was a Leo). But she was also known for her generosity. If a friend complimented something, she would give it to them. She didn't hoard or hold on tightly. To care and not care at the same time.

222 NEW COASTAL

ELEMENTS

Driftwood

rope

shells

seascapes and maps

rattan and cane

lattice

seagrass

nautical artefacts

shutters

big leaves

patterned floors

all shades of blue

stripes

organic shapes

limewash

soft faded denim

white linen curtains

hammocks

224 NEW COASTAL

PLACES
TO GATHER

COLOUR PALETTE: CARAMEL • CHARCOAL • IVORY

1

Surf Shack

A room built in the 1920s – the timber floor and ceiling feel like they were crafted by a shipwright. Earthy colour palettes work well by the coast, something comforting and natural about them.

ELEMENTS

- MODEL OF ANTIQUE BOAT
- MARINE SIGNAL FLAG
- A BAG MADE OF ROPE
- VINTAGE CANE SUNLOUNGE
- A WORKING SURFBOARD
(NOT ONE BOUGHT AS A PROP!)

226 NEW COASTAL

HOW TO CREATE IT 227

PLACES
TO GATHER

2
Courtyard

An oasis and gathering space – the white limewashed walls in Sandstone by Bauwerk Colour make this small courtyard feel lighter.

ELEMENTS

- DRIFTWOOD
- SHELLS
- WHITE LIMEWASH
- LARGE LEAVES
- ROUGH STONE

COLOUR PALETTE: LIMESTONE WHITE • SANDY BROWN • LEAF GREEN

PLACES
TO GATHER

COLOUR PALETTE: SEA GLASS GREEN • ECRU • WHITE

3
Pavilion

The sea mural becomes a painted window,
the focus of the room. The organic shapes contrast
with the modern lines.

ELEMENTS

- ANTIQUE FRENCH MURALS
- DRIFTWOOD
- STRIPED CUSHIONS
- ROUGH CARVED STOOL
- SHUTTERS

232 NEW COASTAL

PLACES
TO GATHER

4

Verandah

If you have a view of the water,
then really it's all about the view.
The room becomes a framing element,
a comfortable space to sit and sink into
the vista beyond.

ELEMENTS

- **BLUE RUG**
- **LARGE LEAVES**
- **SHELLS**
- **RATTAN CHAIR AND LAMP**

COLOUR PALETTE: CARAMEL • OCEAN BLUE • FADED GREEN

234 NEW COASTAL

PLACES
TO GATHER

5
Beach Picnic

A structure out of driftwood.
Something that will be washed away by
the tide. The closer you are to the water,
the closer you are to a dream space.
Shipwrecks & castaways.

COLOUR PALETTE: SAND • WATER • SKY

ELEMENTS
- DRIFTWOOD
- SHELLS
- MUSLIN LINEN CURTAIN

PLACES
TO WORK

6

Palm Desk

I painted this on the wall in a few hours in fast loose brushstrokes, using the vintage painting on page 242 as a guide. Muting the colours to make it more timeless, adding grey to the greens and blues.

COLOUR PALETTE: GREY BLUE • GREY GREEN • NUT BROWN

ELEMENTS

- PAINTED PALM TREES
- RATTAN SHELVES
- STRIPES

238 NEW COASTAL

PLACES
TO WORK

7

Wall of Travel and Adventure

A palette using blues and greens is one of the strongest ways to evoke the coast.

COLOUR PALETTE: SEA GLASS GREEN • PALE BLUE • ECRU

ELEMENTS

- SEASCAPES AND MAPS
- BASKET MADE OF ROPE
- NAUTICAL GLASS BALL
- DRIFTWOOD
- SHELLS
- LARGE LEAVES

**PLACES
TO REST**

8
Verandah Bed

Sleeping out in the sunset,
listening to the waves crashing below.

COLOUR PALETTE: BLUESTONE • SHELL PINK • COCOA

ELEMENTS

- **PATTERNED FLOORS**
- **MUSLIN LINEN CURTAINS**
- **LATTICE**
- **RATTAN**
- **LARGE LEAVES**

HOW TO CREATE IT

PLACES
TO REST

9
Alcove Bed

Simple and minimal
works by the sea.

COLOUR PALETTE: LIMESTONE WHITE • GREY GREEN • ECRU

ELEMENTS

- STRIPES
- BEACH PICTURE

HOW TO CREATE IT

PLACES
TO REST

10

Boathouse

Using blue textiles near a view of water brings the feeling inside. And there is always something elemental about fire near water.

COLOUR PALETTE: BLUE • ECRU • DUSTY PINK

ELEMENTS

- NAUTICAL ARTEFACTS
- ORGANIC SHAPED STOOLS
- STRIPES
- SEAGRASS

HOW TO
BRING A ROOM TO LIFE

We are so used to looking at rooms as two-dimensional images – online, in books, in magazines. But it is not how we experience them in real life. That involves something else: the senses.

Sight. Colour, textures, shapes. These things are all seen in images. But it is also how they combine and harmonise together in a three-dimensional space. The flow of the room and the space in between things can affect how they look.

Sound. Nothing beeping or grating. Better to have music drifting. A record player for that rich warm sound, with a little scratchiness.

Scent. A divine scented candle by Diptyque. The subtle scent of furniture polish on wood, almost undetectable but somehow very pleasing. Plant-derived cleaning products. The smoke from something cooking on a barbeque. A dried eucalyptus branch thrown on a firepit. Muffins baking in the oven.

Touch. A chair that makes you want to sit on it, that looks soft and enveloping. The tactile feel of beautiful fabrics.

Taste. Someone I know told me he was going to dinner at the home of a friend who always cooked beautiful meals – the very thought of her place had become associated with deliciousness.

The Sixth Sense. The sixth sense is intuition. Most people have this in some degree, even unknowingly. The ability to pick up on a good feeling in the room. And sometimes the reverse.

I believe housewarming parties, gatherings and good times really do warm up a room. And things that are meaningful to the person bring something to a space, like a picture drawn by a long-lost friend, a photo of a dearly beloved grandmother.

REFLECTING

Returning home, I feel enlivened from this great trip along different coastlines.

Travel freshens you up, brightens your energy. There are the hard times; when things don't go right. Everyone has had those. But firsthand experience of the world – meeting people who are doing things, trying things – that is precious.

Design is constantly evolving. Seeing new things leads to growth. During the making of this book some things I knew were reinforced. Others, I realised for the first time.

When returning to a familiar room with fresh eyes, the first thing you notice is the clutter that has gradually built up. Clearing things away brings it back to the essentials – like cleaning the barnacles off a ship.

Having empty space in a room gives it a poetry. Sometimes just having space to move through is beautiful.

The cold-water swimming movement has changed coastal experiences. Letting go of the need for comfort leads to a brutal cold shock, then the greater experience of health and vitality. It's a different way of living along cold area coasts.

Whenever it is possible, flood rooms with fresh air. Sea air is enlivening. The pure air in remote areas is a tonic.

Handcrafted and small-batch objects give so much to a space. A feeling of specialness. People can tell when something is made with love and good intention.

Good lighting is paramount. Anything that glows or refracts brings in magic. This can be from the outside too: the lights of the ships way out at sea.

There's something wonderful in the combination of comfort with a stimulation of the mind. Soft cosy textiles, a comfortable chair, a fire. A stack of books to choose from.

I once read a piece in the *New Yorker* about the great British travel writer Patrick Leigh Fermor, who led an extraordinary and adventurous life. Interviewed when he was 91, he told the journalist of his upcoming travel plans to get to Athens from Crete. Rather than take a plane he chose to take the ferry – the night crossing. He didn't book a cabin. When questioned by the journalist, he said he preferred to sit up on deck: he had a bottle of wine and a good book – what more could he want? I like to think of him there, sitting all rugged up on a deck chair under the stars. Reading by the light of the ship's lamp and drinking his wine, surrounded by the power of the great sea.

252 NEW COASTAL

ACKNOWLEDGEMENTS

Thank you to Michael Harry at Hardie Grant for guiding me along the way with good humour and enthusiasm. Simon Davis for your support and deep understanding of the book. Thank you to Antonietta Melideo for your constancy and care for the details. Thank you to Kate Daniel for your insightful edit, and also to Kirstie Armiger-Grant.

Thank you to Daniel New for your marvellous creativity and friendship.

Thank you to Fiona Shillington, Andrew Burges, Will and Julia Dangar, Jessica Eggleston, Fiona Leahy, Kate Alstergren and Sally Tabner for helping me along the way on my Australian trip.

Thank you to Emily Katz and Anne Parker for your tips on Maine. To Carter Bedloe Smith and David Johnson for looking out for me when I was in Maine.

Thank you to my dear friends in the United States: Emily Haas for your magical friendship over many, many years; Peter Ritchie for your generosity and companionship; Clarissa Sebag-Montefiore for your expert edit and wonderful hospitality in New York.

And to Sally Flegg for your photographic excellence and good spirit.

Thank you to the people and companies who loaned me beautiful things for the 'How to Create It' styled set-up section: IB Perryman for your unique rugs and kilims; Cultiver for your fine bed linen, cushions and throws; Pony Rider for your wonderful cushions; The Modern for your elegant armchairs; Daimon Downey for your vibrant artwork; Bruce Goold for your nautical antiques; and Anna Dukes, Francesca Jones, Poppy Roxburgh, Andreas, Nico and Carolyn Harris.

And to Victoria Smith, Hans Blomquist, Jason Grant Seth Smoot, Rachel Claire, Amy Neunsinger, Debi Treloar and Rory Gardiner for your amazing photos.

Thank you to the wonderful people who invited me into their homes and worlds. And to the design experts who shared their insights: Sarah Andrews, Leanne Ford, Jason Grant, Patrick Kennedy, Sean Moran and Emily Ward, Hilary Robertson, Hans Blomquist and Tom Kundig.

Thank you to my dearly beloved mother and father. And the deepest gratitude to my husband, Daniel – for your constancy, support and creative insights.

Throughout this book, we acknowledge Country in each of the Australian places visited.

Where possible, we have sought the advice of the relevant Traditional Owners regarding the accuracy of our wording.

We welcome any feedback or comments from First Nations people about how we have acknowledged Country, or about any other culturally sensitive issues inadvertently raised by *New Coastal*.

Published in 2024 by Hardie Grant Books, an imprint of Hardie Grant Publishing

Hardie Grant Books (Melbourne)
Wurundjeri Country
Building 1, 658 Church Street
Richmond, Victoria 3121

Hardie Grant Books (London)
5th & 6th Floors
52–54 Southwark Street
London SE1 1UN

hardiegrant.com/books

Hardie Grant acknowledges the Traditional Owners of the Country on which we work, the Wurundjeri People of the Kulin Nation and the Gadigal People of the Eora Nation, and recognises their continuing connection to the land, waters and culture. We pay our respects to their Elders past and present.

All rights reserved. No part of this publication may be reproduced, stored in a retrieval system or transmitted in any form by any means, electronic, mechanical, photocopying, recording or otherwise, without the prior written permission of the publishers and copyright holders.

The moral rights of the author have been asserted.

Copyright text © Ingrid Weir 2024
Copyright photography © Ingrid Weir 2024, unless listed below
Copyright watercolour paintings © Ingrid Weir 2024
Copyright design © Hardie Grant Publishing 2024

Artwork acknowledgements: P16 Stephen Ormandy, Louise Olsen, Tyron Layne, Pornthep Chipfong; P17 John Mackie, Daimon Downey; P18 Daimon Downey, Yala Yala Gibbs Tjungurrayi; P20 Brett Chan, Beni Single, Daimon Downey; P22/23 Daimon Downey; P34 Siegfried Haas, ceramics by The Haas Brothers; P36/7 Bianca Fields, Genieve Figgis, The Haas Brothers, Simon Haas, Ameesia Marold; P43 Rafael Uriegas; P93 Grant Drumheller; P100 Desmond Sweeney; P105 Rafa Rose Sweeney; P120 Rikkianne Van Kirk; P124 Vincent Arcilesi (model), Anna Koeferl (vase); P183 Susan Rothwell (painting); P196 Murray Hilton (photograph); P239 John Beerman (seascape in arch), Rocco Fazzari

Additional photography: P8, 190 Rory Gardiner (Tom Kundig's Bilgola beach house); P193–5 Victoria Smith; P200 Jason Grant; P203 Amy Neunsinger for Crate & Barrel, styled by Hilary Robertson; P204 Hans Blomquist for Bauwerk Colour; P206–7 Debi Treloar for Zara Home, styled by Hans Blomquist; P209–11 Seth Smoot; P212, 214–15 Rachel Claire; P252 Shyam Ediriweera; back cover author portrait by Sally Flegg

Excerpt from "What I Believe" by Albert Einstein copyright © The Hebrew University of Jerusalem. With permission of the Albert Einstein Archives.

"Asphodel, That Greeny Flower" (three-line excerpt) by William Carlos Williams, from ASPHODEL, copyright ©1944 by William Carlos Williams. Reprinted by permission of New Directions Publishing Corp and Carcanet Press.

"Dogfish" (two-line excerpt) from Dream Work copyright © 1986 by Mary Oliver. Used by permission of Grove/Atlantic, Inc. Any third-party use of this material, outside of this publication, is prohibited.

A catalogue record for this book is available from the National Library of Australia

New Coastal
ISBN 978 1 74379 917 8

10 9 8 7 6 5 4 3 2 1

Publishers: Michael Harry and Simon Davis
Managing Editor: Loran McDougall
Project Editor: Antonietta Melideo
Editor: Kate Daniel
Design Manager: Kristin Thomas
Designer: Daniel New
Photographer: Ingrid Weir
Production Manager: Todd Rechner
First Nations consultant: Jamil Tye, Yorta Yorta

Colour reproduction by Splitting Image Colour Studio
Printed in China by Leo Paper Products LTD.

MIX
Paper | Supporting responsible forestry
FSC® C020056

The paper this book is printed on is from FSC®-certified forests and other sources. FSC® promotes environmentally responsible, socially beneficial and economically viable management of the world's forests.